HAUNTED
CAPE
GIRARDEAU

HAUNTED CAPE GIRARDEAU

WHERE THE RIVER TURNS A THOUSAND CHILLING TALES

JOEL P. RHODES

HAUNTED
America

Published by Haunted America
A Division of The History Press
Charleston, SC 29403
www.historypress.net

Front cover: Courtesy of Jeanie Rhodes.
Back cover, right: Courtesy of the Cape Girardeau Convention and Visitors' Bureau.

First published 2013

ISBN 978.1.54020.755.5

Library of Congress CIP data applied for.

To Alex, Olivia and Ella.
And to think it all started on Halloween.

CONTENTS

CONTENTS

PREFACE

Imust admit that I was more than a little reluctant to take on this
project with so much of my research on children in the Vietnam era
just now starting to take shape, but my wife and muse, Jeanie, convinced
me that writing about haunted Cape Girardeau would be thoroughly
enjoyable. As usual, she was right on the money.

This book has indeed been a real pleasure to work on, and I would first
like to thank Ben Gibson at The History Press for offering me the gig to
begin with.

A great deal of the book grew out of two radio programs I was
fortunate enough to have collaborated on with Jacob McCleland at
KRCU. Working with Jacob and his staff on *The Ghosts of Cape Girardeau*
and *The Ghosts of the Mississippi* (which, by the way, won the 2011 Missouri
Broadcasters Association's First Place Award in the Documentary/
Public Affairs Category) was such a great experience, and I owe a lot to
Jacob for how I conceived this project, how the topics were ultimately
framed and which of the interviews I included. I want to specifically
thank Jacob for allowing me to use excerpts of his first-rate writing from
those original scripts for *Haunted Cape Girardeau*.

I also want to especially thank Christy Mershon in Southeast Missouri
State University's continuing education program for graciously sharing
her considerable knowledge of Cape's haunts and spooky stories. Christy

and Tom Neumeyer, her fellow expert on all things haunted in Cape, were invaluable to me in laying out the parameters of the book, and I am indebted to both of them. If you are interested in touring some of the haunted sites highlighted in these pages, I highly recommend taking Christy and Tom's excellent haunted tours of Cape Girardeau offered each fall.

Likewise, the expertise of the Paranormal Task Force informed my research considerably with its analysis and narratives. I specifically would like to thank Greg Myers, the president of the Paranormal Task Force, for granting permission to use photographs from its website, which I must say is a great resource for anyone interested in paranormal investigations throughout the region.

At the inevitable risk of forgetting someone, I would also like to extend my sincere appreciation to Chuck Martin and all my friends at the Convention and Visitors' Bureau for being such jovial storytellers and for allowing me to use several photographs from the website (and, of course, to Stacy Dohogne Lane for scanning them at the precise resolution). Thanks, also, to Lisa Speer and her outstanding staff at the Southeast Missouri State University Special Collections and Archives for their invaluable support with the historic photographs. Thanks, as well, to Katherine Webster, Dan Bryant and Frank Nickell, but particularly to two outstanding former students, Sam Sampson-Kincade and Kathryn Vangilder, for all their help.

As with all my writing, my wife Jeanie's inspiration and guidance is integral to the process. As we "talk" through each page, her stories and enthusiasm always shape the finished product. One of my all-time favorite memories will be the Saturday afternoon we spent with our daughters, Olivia and Ella, driving around Cape Girardeau taking pictures of haunted houses (Ella is the little girl at the Pike Lodge), drinking chai tea and stumbling onto a Sprigg Street monkey. Thanks kiddos.

Portions of Neumeyer, Nickell and Rhodes's *Historic Cape Girardeau: An Illustrated History* (Lammert Publishing, Inc., 2004) have been used with permission from the Historical Publishing Network. Additional excerpts from "The Ghosts of Cape Girardeau" and "Ghosts of the Mississippi" are used with permission of National Public Radio, KRCU.

INTRODUCTION

C ape Girardeau is a river town—at the same time both *on* and *of* the Mississippi. For nearly 250 years, the community's deep roots have run directly back to the "Father of Waters." On its muddy banks, eighteenth-century traders located a rough riverfront outpost near the stone promontory jutting out over the Mississippi—by today's Cape Rock—precisely because it was an easily identifiable landmark for river traffic. Jean Baptiste Girardot, a French marine stationed at nearby Kaskaskia in present-day Illinois, lent his name to this frontier trading post he helped found, and as early as 1765, French maps clearly show "Cape Girardot." Clinging to the river on the very edge of western civilization, the isolated little village grew sporadically during the colonial era but slowly established itself as the trading, milling, ferrying, meeting and legal center for one of the five Spanish districts in the Louisiana Territory. For trappers to the south, who brought furs and hides out of the largest wetlands in North America, and for farmers to the north and west, bringing produce and livestock from family farms, Cape Girardeau became the region's economic and commercial lifeline.

Beginning in the 1830s, steamboats tightened Cape Girardeau's relationship to the river, as virtually the entire town—warehouses, businesses, courthouse, seminary and homes—intimately faced the

"Mighty Mississippi." The regular comings and goings of steam-powered packet boats with names like the *Tennessee Belle, Piasa* and *Cape Girardeau* set the rhythm of life along Cape Girardeau's levee. Each steamboat announced its arrival with its own distinctive signal, a combination of long and short blasts from the steam whistle. These signals, heard all over town, sent merchants and citizens swarming to the levee to pick up merchandise, greet passengers or simply enjoy the spectacle. As many as six boats could be tied to the levee at any time, and in a carnival-like atmosphere, the riverfront teemed with humanity whenever the huge vessels arrived. After tying up on the steel rings embedded in the levee's cobblestone, sweaty "roustabouts" jumped off the gangplanks to unload merchandise stacked on the first deck and load local produce and commodities waiting for them by the river. These roustabouts, most always African American men hired in St. Louis, sang as they toiled, and since few could read, they created an elaborate system of nicknames for local merchants to help them remember what cargo went where. Amongst the crates and bundles, the curious milled about to check out what new merchandise local stores would soon be offering and if their neighbors had made any major purchases.

The arrival of the steamboats, and their passengers, cemented the town's position as an entertainment center. Cape Girardeau offered attractions that were scarce in the rural hinterland, including horse races, fairs, circuses, parades and theater, as well as more risqué amusements such as houses of gambling, liquor and prostitution. It also attracted its own distinctive brand of adventurers and wayward souls. River folk were a restless lot, coarse men and vulgar women drawn to the siren song of romance, vice and easy money along the levee. Over the generations, any number of the lawless, sawdust taverns and raucous brothels near Cape Girardeau's riverfront bore witness to exhilarating triumphs and excruciating tragedies, uncommon virtues and shameful sins, fortunes quickly made and just as swiftly squandered, dreams realized and painfully dashed, lives well lived and violently lost.

As railroads began to replace the river as the dominant mode of transportation at the turn of the twentieth century, Cape Girardeau's well-deserved reputation as the most colorful community between St. Louis and Memphis only grew. Yet the coming of the railroads, and later the interstate system, occasioned a curious shift in the town's orientation. Increasingly, Cape Girardeau turned away from the

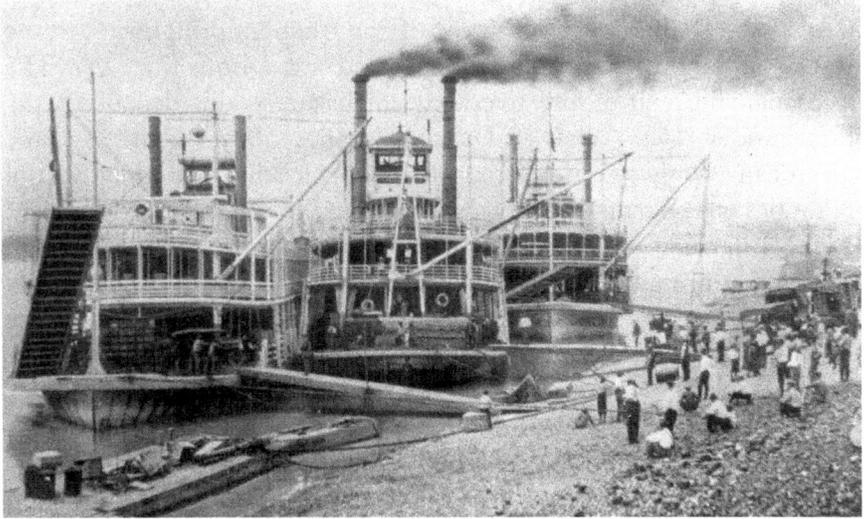

Steamers tied up along Cape Girardeau's cobblestone wharf. *Courtesy Southeast Missouri State University Special Collections and Archives.*

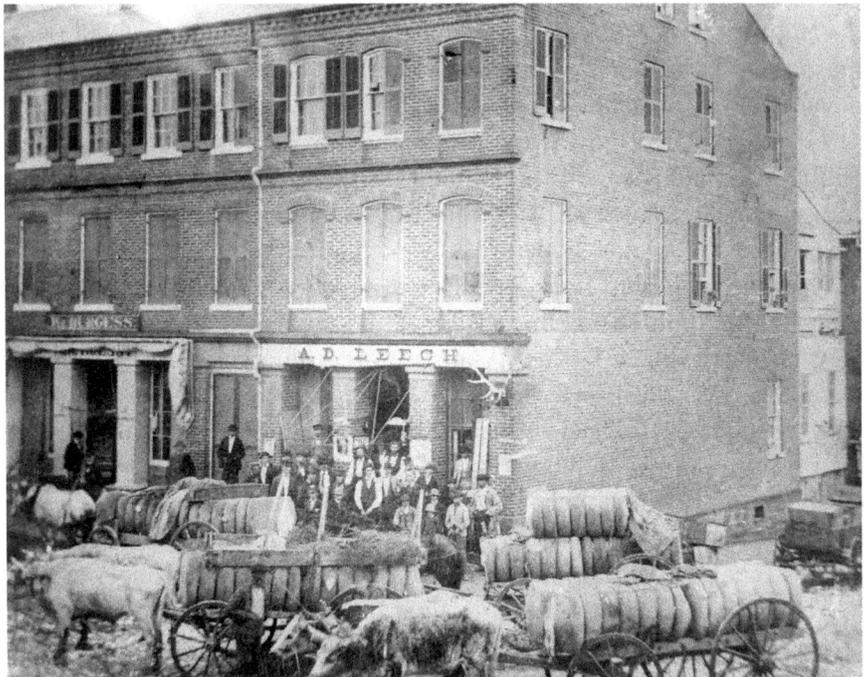

Cape Girardeau's nineteenth-century riverfront bustling with commerce and entertainment. *Courtesy Southeast Missouri State University Special Collections and Archives.*

Mississippi, abandoning it in favor of the tracks and highways to the west as commerce and population moved away from the river. The accompanying end of the riverboat era hastened this decline of the historic downtown. What had once been the vibrant heart of Cape Girardeau along the waterfront fell oddly silent with only wistful memories of its former vitality drifting amid the disrepair and vacancy. By the 1960s, an imposing flood wall kept the community from even looking at the muddy water from whence it came. Nevertheless, it is precisely here, in these forsaken places closest to the waterfront, where the river turns a thousand chilling tales of ghostly encounters and unsettled spirits that refuse to go quietly into the night.

On one hand, the powerful and dark water of the Mississippi itself appears to beckon the supernatural. Many paranormal investigators believe those restive spirits anxious to communicate with the living require some energy source—water power, for example—in order manifest themselves from beyond. Perhaps this would explain why cities such as Charleston, South Carolina; San Francisco, California; and Savannah, Georgia, are considered among the most haunted places in the country. It might also account for the rich and timeworn folklore of unexplained phenomena along the Mississippi because, for shear raw power, the river has few equals on earth.

The longest river in the world if measured from the headwaters of the Missouri River to the Gulf of Mexico, over 40 percent of the continental United States is within the Mississippi's boundaries. The Mississippi River Valley is nearly 20 percent greater than that of China's Yellow River, double that of the Nile and Ganges and some fifteen times larger than the Rhine's. Only the exotic Amazon and Congo have larger drainage basins. What is more, the Mississippi's immense force almost has a life all its own. As river scholar John Barry attests, dynamic combinations of velocities, variations in depth and a sediment load running in the millions of tons a day drive the water relentlessly downstream. By the time it gets to New Orleans, that water is moving at nearly four and a half million gallons a second. Even casual observers can see that the Mississippi does not really *run* in the traditional sense as much as it *roils* like a massive uncoiling rope, colliding with the land at its curves and methodically scouring the bottom.

For those reasons alone you would expect Cape Girardeau to be especially prone to the unexplainable, and in fact, over the years a number of visiting parapsychologists and paranormal investigators

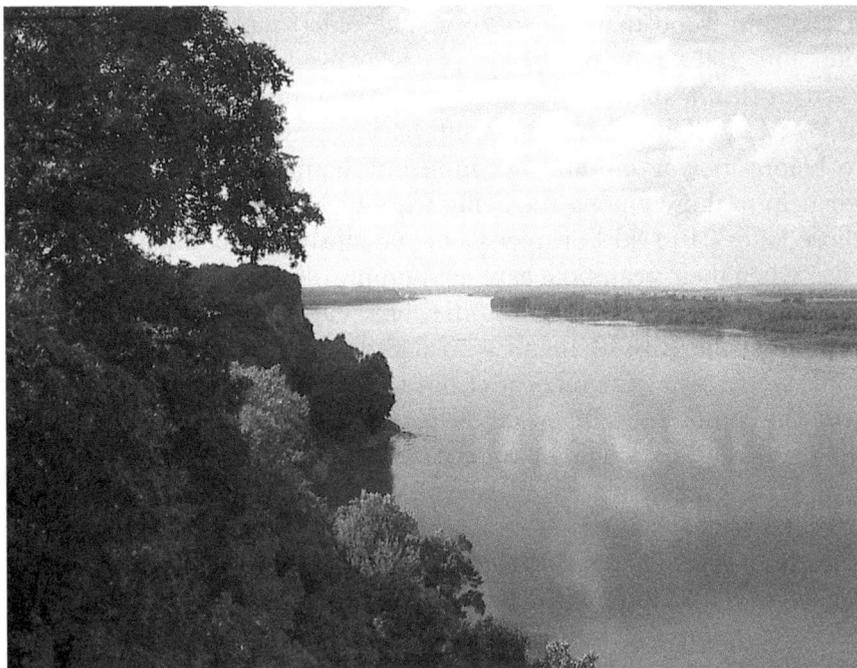

The Father of Waters rolling south past the high bluffs of Cape Girardeau County. It has also been suggested by those sensitive to such matters that Cape Girardeau's proximity to the latent energy of the New Madrid seismic zone—a fault line that generated a series of catastrophic earthquakes from 1811 to 1812 so intense that the rumbling rang church bells on the East Coast—also affords a constant source of additional power to propel those seeking to cross over. *Courtesy Cape Girardeau Convention and Visitors' Bureau.*

have also characterized it as one of the most "active" places in the United States. Little wonder, then, that for generations before the town even existed, Native Americans and Europeans maintained an eerie lore of restive specters and menacing apparitions who wandered the surrounding bluffs and shoals. These ranged from an ancient Indian legend that warned of a phantom, man-eating gray wolf haunting Cape Rock to the pitiful sobs of drowned children plainly heard by keel boaters drifting close to the bank on particularly dark nights. On the other hand, considering the hundreds of years in which humanity has been gathering in this port, some researchers also believe that the energy of those wayward souls and traumatic acts has never really left but is, instead, imprinted on the porous surfaces of the very limestone,

bricks and wood that still make up the oldest parts of town. Simply put, the restlessness of the people who lived here is indelible, and even in death, their restlessness remains. Some, like the lonely Belle at Port Cape Girardeau restaurant, have unfinished business to attend to before moving on, and her mournful haunting may well be a cry for help to those among the living who might assist her in completing those labors. In Old Lorimier Cemetery, tortured boatmen lost in the river when their steamboat exploded simply refuse to accept their tragic scalding and stay behind to wander those earthly grounds. Then there is Alex at the Rose Bed Inn who nightly ponders his untimely and, some would say, wrongful death from an easy chair in a darkened parlor with the comfort of a fine cigar. At Rose Theatre a ghostlike gentleman affectionately and longingly watches the drama of play rehearsals from seat D28, similar to the old lawyer who took comfort in remaining within his beloved home even though it had become a fraternity house after his death. There are also agitated entities like Mad Lucy that are cursed to haunt Bloomfield Road with unworldly screeches and wails. All their various supernatural energies, both positive and negative, have been absorbed into the landscape and architecture of Cape Girardeau. And sometimes under the proper conditions—whether you are together with friends at a social gathering, studying for finals in the dorm or alone in a particularly creepy old house—their energy can be replayed with enough vibration for the living to experience it.

Similarly, in those neighborhoods of Cape Girardeau where the fabric is oldest and now most neglected, where the pace of life was the quickest but is now most stagnant, decay seems to conjure its own unexplained happenings, hauntings and ghostly encounters. For a time, the oldest parts of Cape Girardeau, specifically those associated with its river heritage, were considered by many forward-thinking people to be the unfortunate reminders of a bygone golden age, which has since had its progress replaced with failure, its optimism with despair. Even the hallowed ground of Old Lorimier Cemetery, the final resting place of many of the town's founders and often one of the first spots mentioned when people talk of haunted Cape Girardeau, suffered through an extended period of neglect and vandalism. This natural fear of decline may even reflect our human trepidation about our own aging process and frail mortality.

In these waning places, ghosts are often about reoccurrence and reappearance. Where engaging people were silenced, once vibrant

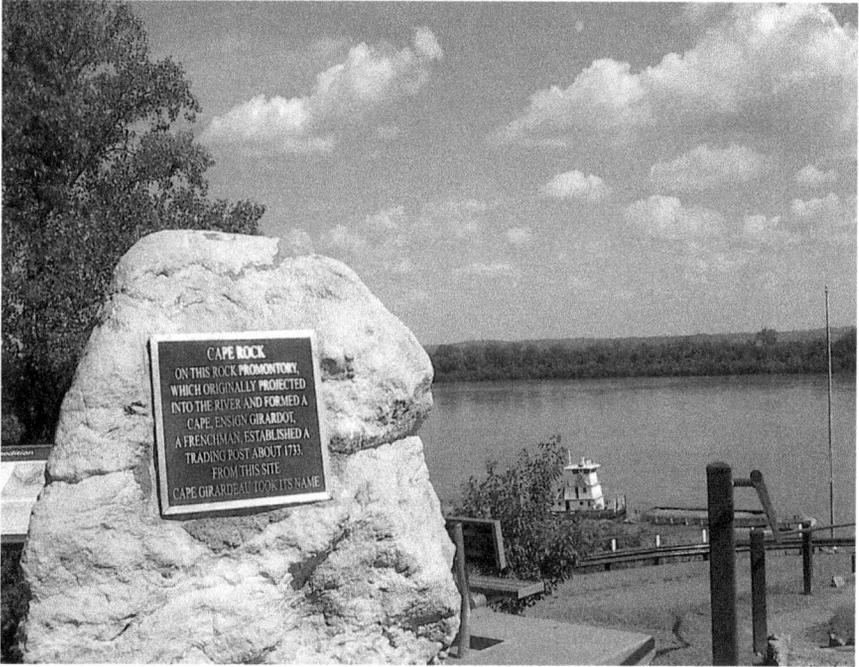

Today, a plaque commemorating Cape Rock is all that remains of the landmark where Jean Baptiste Girardot located his eighteenth-century trading post. *Courtesy Cape Girardeau Convention and Visitors' Bureau.*

theaters emptied or bustling levees forgotten, spirits echo what was lost. For instance, a classic Victorian-style haunted mansion like the Glenn House, of which Cape Girardeau has its share, began as a magnificent home filled with the vivacity and hope of its owners before falling on hard times. Dr. Frank Nickell, the world's leading authority on all things southeast Missouri, followed this particular line of reasoning for KRCU radio's *The Ghosts of Cape Girardeau*, observing that

> *great houses that once were showplaces of wealth and stability will change over time. We don't have the family size anymore, so we have big houses with two people living in them. Or big houses with one person living in them. That's difficult to maintain, so we often see houses, old houses, historic houses change. As the landscape changes, the buildings change, and consequently you'll see a big old house, Victorian in style and architectural features, or a Queen Anne House with gothic*

*windows…as that house is no longer used to the full extent—you don't
have eight kids or seven kids in the family—you now have maybe an
older couple living there, and they don't maintain the upstairs as well.
They don't take care of it. They don't get out and paint it themselves.
As a result the house deteriorates a little bit, and it becomes more
mysterious. Questions are asked about it, and those houses sometimes
become the basis of haunted houses. You can see that in any river
town, especially, that once had great captains and captains of industry
who lived there and had a lot of money and built an opulent house
showplace facing the river. Today those houses no longer meet the same
needs. They may stand empty. They may be for sale. They may sell
and resell. And the result is they deteriorate a bit and that adds to the
mystery of that house.*

Wherever you believe they come from, or why they appear as they
do, the peculiar hauntings of Cape Girardeau are integral parts of the
rich heritage of life here on the river. They are important now more so
than ever because at the onset of the twenty-first century, the town is
reversing its decades-long disregard of the Mississippi and once again,
figuratively and literally, returning to its roots along the river bank.
This "back to the river movement" can be seen in a variety of places.
Chief among these are the major rehabilitation and renovation of the
antebellum St. Vincent's Seminary into its modern incarnation as the
Southeast Missouri State University River Campus and the construction
of the Bill Emerson Memorial Bridge. Both have helped reorient the
town eastward while at the same time renewed interest in the historic
Old Town Cape district and accompanying riverfront casino.

You see, Cape Girardeau's river renaissance has stirred the
echoes, so to speak, opening new doors for ghoulish appearances.
In a number of recently renovated older houses, new owners, eager
to see their one-hundred-year-old Queen Annes restored to their
former glory, have instead upset resident spirits with all the changes
being made. Within months of moving in, doors slam in the middle
of the night and cold spots are felt on the staircase. There are
certain houses with rooms where unseen footsteps on the hardwood
floor keep skittish pets from entering or where the disembodied
sounds of children playing in a third-story attic keeps entire families—
children and adults—from venturing upstairs in their own home. The
only recourse to pacify the unfriendly presence is sometimes leaving

behind their dreams and investment. So, too, have prospective business owners downtown awakened malevolent forces with new construction, returning to the worksite each morning to find power tools removed from locked toolboxes and stacked neatly in completely different rooms. As with many Mississippi towns, frightened entrepreneurs along the river invariably associate the more spiteful entities with an ancient voodoo conjurer from New Orleans whose violent death in a drunken, back alley knife fight doomed his black magic–tainted soul to endlessly wander the district's restaurants, boutiques and antique shops. Since the opening of the restored River Campus, students and theater guests alike speak of seeing odd flashes of light in dark hallways, unrecognizable shadows seated in recital halls, doors shutting and locking by themselves and earnest conversations emanating from empty rooms.

While it appears recent historic preservation endeavors are breeding the next generation of spectral tales, by openly embracing Cape Girardeau's river heritage, the town is also rediscovering many of its forgotten ghost stories. On any given evening, a number of area paranormal research groups actively investigate the unexplained in downtown businesses and private homes. Each October, hundreds of the curious follow guides Tom Neumeyer and Christy Mershon on a very popular walking tour of the downtown's spooky sites. And in the following pages, we will explore a few of the phantoms, ghouls and shadowy figures from along the Mississippi River. Perhaps all this attention will calm haunted Cape Girardeau's restless spirits along the river. Or maybe it will only serve to embolden them.

DEATH ON THE RIVER

For all the romance of life on the river, the reality of riverboat travel, especially in the nineteenth century, could be quite hard and often cruel. Steamers hauling both passengers and freight were sometimes short on creature comforts, and the treacherous nature of the twisting, churning Mississippi made navigation painstakingly slow. Accidents were an unfortunate but all too common occurrence, and from the vantage point of Cape Girardeau's levee, generations of townspeople lived with the devastation and carnage. The river's fierce and unpredictable currents pulled even experienced pilots' boats down, leaving undiscovered wreckage strewn along the bottom to this day. Communicable diseases, such as cholera, ravaged unwary travelers thrown together onboard and terrorized the town with the threat of an epidemic when they came ashore for treatment. Chance fires rapidly consumed entire vessels and their flammable cargo. When they occurred, dense, acrid smoke would hang heavy over the river valley by day, or at night, the roaring flames of a riverboat blaze would illuminate the sky for miles around, the glowing signal of a catastrophe unfolding up or downstream. Violent blasts from combustible payloads could level top decks or, as in the case of the *Sea Bird*, damage neighboring buildings on land. In this 1848 calamity, a fire onboard the freighter,

docked below St. Vincent's Seminary, ignited its cargo of gunpowder, and the resulting detonation blew out every window in the college and lifted the entire roof off by several inches. Worse still were the deafening boiler explosions that tore apart some steamers, scalding the flesh off doomed crew members and burning others beyond recognition.

When conditions were right, Cape Girardeau could hear not only the discharge but also the painful shrieks and agonized screams of the survivors carrying over the water. Because rescue boats sometimes brought the casualties of nearby disasters to Cape Girardeau first and because many passengers boarded ill-fated crafts at the Cape landing, the town often experienced this kind of misery firsthand. A *New York Times* article, reporting such a fearful sight in 1886, describes the event: "The scene at the wharf as the *Eagle* landed in Cape Girardeau with the dead and wounded [was] the most pitiable ever witnessed. As the passengers were residents of that city, the news quickly spread, and crowds of people hurried to the landing to learn the fate of friends and relatives." In the weeks following a wreck, floating debris—sundry barrels, planks and bundles—continued to wash up on the levee, as did the bodies of horses, goats, pigs and humans. An unmarked mass grave in the southeast corner of Old Lorimier Cemetery contains more than a few of these bodies.

There are parts of the Mississippi, and places along its banks, haunted by this horrible waste. Modern barge captains and crews on workboats entering these parts of the river have for years told of seeing unexplainable lights playing and bouncing across the water and hearing ghostly cries and laments. One of the most infamous is the peculiar stretch of river a few miles above Cape Girardeau in the area known as Neelys Landing. Here, two of the most tragic riverboat fires, the *Stonewall* in 1869 and the *Mascotte* in 1886, consumed over three hundred lives. In the chilly twilight of a Wednesday evening, October 27, 1869, the passenger and freight steamer *Stonewall* eased smoothly through the water just below Neelys Landing, some 125 miles below St. Louis. The good ship had left the wharf in Missouri's largest city the day before, fully loaded and bound for New Orleans. With the river so low, the ship had settled into a steady, slow pace. Passengers milled about on their way to dinner, some passed the time with idle conversation and a few read. A group of men played cards amid bales of hay stacked high on the crowded deck, their candle burning carelessly and fatefully close to the bundles. The fire apparently had been smoldering in that grass

for quite some time before an alarm sounded from a roustabout, and with brisk winds fanning the flames, it spread quickly through the bales well beyond the control of the crew. Shrill screams of "fire" pierced the thick black smoke as panicked passengers scurried to retrieve their companions and belongings. Many were disoriented and lost, not knowing where the flames were coming from. As a passenger from Texas described it for a newspaper, there was "great confusion and excitement prevailed on the deck below."

Elisha P. Watson, a carpenter on the *Stonewall*, and one of only four of the crew to survive, offered the most lengthy and magnificently detailed account of the disaster for the *Indiana Messenger*:

The first I knew of the fire was this: The officers, including myself, had just sat down to supper, and we heard on[e] of the negroes call out "fire, fire, the boat's afire"...A second or two after this here was a cry of fire again, intermingled with a sound of excitement and confusion, and every one at the table was instantly conscious that peril existed. We all jumped up from our chairs and scattered, I ran to the forward steps and descended amid a wild stream of passengers, officers and crew—one madly rushing, struggling, closely jammed mass, impelled by a common desire—to escape from the horrors of a burning Mississippi steamer. I saw the fire—we all could see it—gathering headway rapidly, as some of us had seen it before on other boats and all had read of it. The boat was under way, with the wind from the South, blowing the flames rapidly form [sic] room to room and from stanchion to deck.

Admonishing the frantic to be calm and orderly, the pilot, Edward Fulkerson, drove the *Stonewall* toward a rock formation known as the Devil's Tea Table, below Neelys Landing at the mouth of Indian Creek, for an emergency landing. Although the boat ran aground on a gravel bar still 150 feet from the Missouri bank, the captain directed those in his charge to escape the rising flames and intensifying heat by wading the rest of the way to shore along the bar. As the first passengers abandoned ship into the frigid water, no more than 2 feet deep at first, the current swung the *Stonewall* around and allowed the south wind to whip the flames into an inferno. Watson recalled what happened:

The fire was now making dreadful quick headway, the wind blowing through the boat from the stern. The stage plank protruded over the guard about fifteen feet. I tried to get others to help me launch it overboard, but no attention was made to my request. I couldn't get 'em to hear to anything; they were panic struck, and jumping and tearing and struggling and running over one another; I tumbled over on the deck and was trampled on till I hardly felt [the breath] in my body; I got up as soon as possible and threw off the heavy coat I had put on previously, ran along the stage, as I thought this the only chance for my life, and jumped into the river.

What the captain had not known, however, was that at the end of the sand bar was a hidden trough over six feet deep. Those wading their way to shore plunged into the icy, dark waters, which swept dozens away. Those left on the *Stonewall* were "caught like rats." Witnesses recalled that "some of the passengers were seen to walk into the flames" while "others jumped into the river, some forcing horses from the lower deck to swim while they clung to the animal's tail." A Kentucky passenger swam ashore with a woman and then, on the direction of her pleas, swam back to retrieve her child, along the way shaking off the panicked grasp of a drowning man desperately trying to pull him under.

When Elisha Watson entered the water it was over his head. He could not swim, but as he remembered:

I got hold of what seemed to me to be a bundle of clothes; the boat was about two hundred yards from the bank of the river—on the Missouri side—and I was trying to get there as quickly as possible; the water was almost alive with people, mules were loose previously on deck, and someone I suppose cut the horses loose, and the turmoil drove them overboard. The bundle of clothes I struck didn't support me well, and I went for a ladder. Grasping the ladder was a negro. He kept turning it round and round, until I thought I would be lost, and I call to him "For God sake don't keep turning the ladder, and we'll both get ashore!" He must have been out of his wits, for he kept turning the ladder, fell off and went under. I made a dash for a blae [sic] of hay, and got on it. The band burst and the hay bale fell to pieces. I then got a small board under each arm, and by this means and a good deal of kicking up of my heels, got to the bank.

While I was in the water, I saw a woman drown right along side of me, but I could not help her. She was an Irish woman and had been a passenger on the deck. The shrieks and cries of the people drowning, or about going under, were heart-rendering [sic], and made me almost crazy. One of the most terrible sights I ever saw was a drowning child. It came floating past me, but I saw only the little hands and wrists raised, and I thought her last and smothered words were "mother, mother." Her lips, head, body, so soon to be cold and lifeless, were floating, sinking beneath the rushing water.

The glow from the blaze towering into the night sky, and the frightful cacophony of the fire drew local residents for miles to help. Skiffs were launched to rescue those they could, but approaching the *Stonewall* became nearly impossible because of the extreme heat. Some lifted from the floating debris were so badly burned that they died in the rowboats before reaching the bank. And with hundreds of people in the water, many at Neelys Landing could only watch helplessly as drowning passengers floated by them, including the captain, who clung to a piece of wreckage. On the river's edge, fires were built from fence rails torn from posts to keep the rescued passengers warm. Some, including Elisha Watson, were transported to nearby houses while others were loaded on the steamer *Belle of Memphis*, which eventually arrived on the scene to evacuate the living back up river.

By morning, Cape Girardeau County officials had also made their way to Neelys Landing to sort through the destruction. Pronouncements of death were rendered, bodies were identified that could be and the grisly task of sorting through possessions in order to notify kin was begun. The county determined that out of 252 passengers and crew on the *Stonewall*, only 30 made it out of the water alive, including just 1 woman. Nearly 60 of the unrecognizable were buried together in a long mass grave on the Cotter farm. A gnarled cedar tree marks their tomb. What little salvageable material that remained was sold off, but a man downstream recovered a horse for free, naming the scarred beast Stonewall. Since the *Stonewall* fire, the portion of the Mississippi where it occurred has come to be known as Stonewall Bar, and well into the twentieth century, locals said that "at low water, broke queensware, coal, nails, bits of iron and even bones [were] still reminders of the disaster."

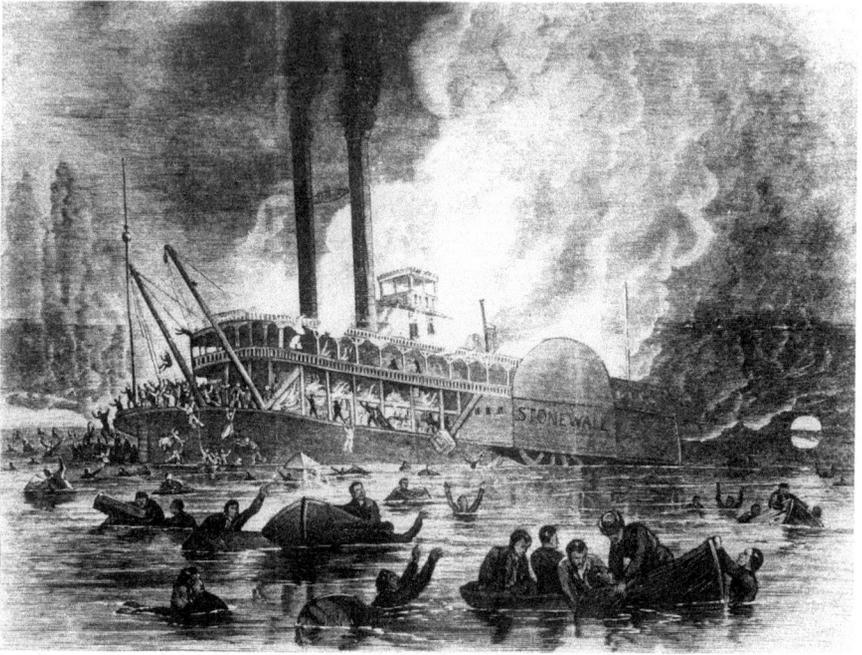

Two hundred and twenty-two people died in the *Stonewall* fire on October 27, 1869. *Courtesy Southeast Missouri State University Special Collections and Archives.*

Nearly seventeen years to the day after the *Stonewall* tragedy, the steamer *Mascotte* caught fire just above Neelys Landing on October 5, 1886. A violent explosion in the engine room ripped through the decks, scalding many crew members and roustabouts with steam, and within minutes, the entire vessel was engulfed in flames. The captain guided it toward the Missouri side, but the blaze reached the pilot's house before he could lower the stage plank. With no one at the wheel, the swift current swept the bow out into the river again, which brought the stern in closer to the bank. As the burning *Mascotte* continued to drift, passengers on the stern leapt into the deep water, but most stampeded toward the still upright gangplank. Remaining crew members struggled to maintain order while lowering the gangplank, barking out that women and children would be first, but here again panic drove people forward and a number were shoved off the plank. Then, with the gangplank overflowing, the smokestack overhead gave way, falling directly onto the passageway. Dozens were

crushed instantly while those who dove into the Mississippi to avoid its fall were swept along and drowned with the others.

A nearby towboat, the *Eagle*, reached the *Mascotte* relatively quickly, and its crew began pulling bodies from the river. Although many were rescued, survivors later believed that the *Eagle* could have saved many more by simply pushing the *Mascotte* to the bank so that those still on board could safely escape.

When the *Eagle* landed in Cape Girardeau hours later, the "pitiable" scene reported in the *New York Times* unfolded. Advance news brought worrying family and friends to the riverfront to anxiously wait for the dead and injured to be offloaded in their hometown. Doctors and volunteers turned the landing into a medical triage among the onlookers, taking care of the worst cases immediately. Those crew members so horribly scalded and burnt, whom nurses described as not dead but soon to be, were given as much comfort as possible. Identification of the dead and missing took an agonizingly long time, especially in those cases where corpses were beyond recognition and papers had been washed away. Included in the thirty-five people killed on the *Mascotte* were two small daughters of a bookkeeper for the still fledgling "Houck lines," the provincial railroad empire of Louis Houck that would eventually help draw the era of the great steamboats to a close.

This much pain and suffering would understandably be imprinted on a river town. In addition to spectral lights on the Mississippi and disembodied voices along its edges, around Neelys Landing, the ghosts of passengers and crew buried in Old Lorimier Cemetery have been seen making lonely nighttime pilgrimages back to the water. More eerily still are the misty human fingers suspended chest deep in the river that a local psychic can see. There are literally thousands of these spirits gently floating and bobbing in the dark current. The Mississippi is peopled with them here, she says, up and downstream as far as the eye can see. All seem trapped somehow in the muddy water, gazing longingly toward the safety of the distant bank or the warm embrace of those on it. Yet for some reason, their mouths remained forever closed, unable to speak, perhaps still bearing silent witness to their death on the river.

SOUTHEAST MISSOURI STATE UNIVERSITY

Considering the human drama of the college experience, campuses are notoriously fertile ground for the supernatural. Here, the exhilaration of an ambitious student's wide-eyed aspirations wrestle uneasily with gnawing anxieties over failing to meet academic demands and parental expectations, all within the emotional cauldron of extended adolescence. This restless energy of newly emancipated youth, almost palpable when you stroll among the student body, may well be imprinted in the limestone lecture halls and woodwork of the dorms in which they reside. Curious and naïve students are also drawn to the unexplained, and if you believe in the old adage that by simply talking about spirits you can summon them, then imagine the outcome when late night shenanigans at a fraternity or sorority house involve the Ouija board. The folklore of Southeast Missouri State University seems to confirm higher education's heightened potential for the paranormal. Ask virtually any freshman, and he or she will be able to tell of the legendary tunnel system thought to run mysteriously under the campus or of a reliable friend's firsthand sighting of old Sadie Kent's translucent ghost drifting among the bookshelves in the library that bears her name (any similarities to the opening scenes from the movie *Ghostbusters* is purely coincidental, they say). Yet a number of places at Southeast have more complicated and eerie stories, placing the university as one of the most haunted places in Missouri.

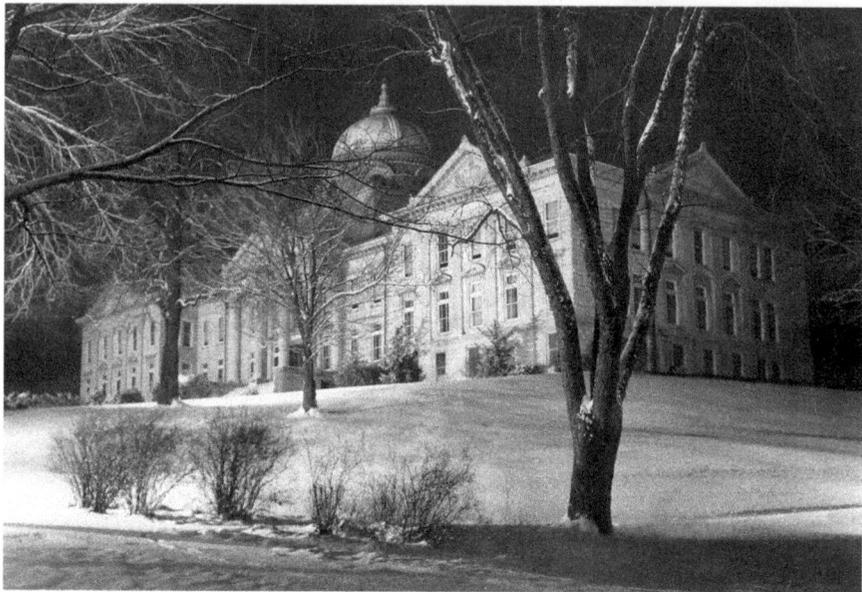

Academic Hall, the centerpiece of the Southeast Missouri State University campus, circa 1949. *Courtesy Southeast Missouri State University Special Collections and Archives.*

Founded in 1873 as one of the state's teachers' colleges, the university sits prominently on the high ground to the north of old town Cape Girardeau, on the remains of a Civil War fort constructed to protect the town from Confederate advances. After a fire destroyed the original structure of what was then Southeast Missouri Normal School, the majestic Academic Hall was completed in 1905 as the centerpiece of campus. Using limestone quarried on the site, local builder Edward Regenhardt oversaw construction of architect J.B. Legg's ambitious neoclassical design, which combines elements of Greek and Roman architecture and was obviously influenced by the Chicago and, recently completed, St. Louis World's Fairs. Just as it does today, the magnificent copper dome of Academic Hall dominated Cape Girardeau's landscape, standing as a beacon of higher education across all of southeast Missouri.

Throughout the twentieth century, as the name changed from Southeast Missouri State Teachers' College to Southeast Missouri State College, the school underwent significant enrollment increases, dynamic changes in its curriculum and a spirited building program. By the mid-

1970s, when it officially became Southeast Missouri State University, enrollment reached seven thousand while an accompanying academic expansion moved the college away from its traditional role of simply training teachers and introduced many new programs and degrees, including graduate study in nursing, business, computers and the liberal arts. In a little over a generation, the university also physically grew from just a handful of buildings to nearly two dozen, which include the construction of Magill, Brandt, Grauel and Memorial Halls, the Parker Physical Education Building, the Dearmont Quadrangle, the Towers Dormitory Complex and the University Center.

ROSE THEATRE

A number of locations that were part of this growth developed reputations for the ethereal. Almost immediately upon opening in 1956, Brandt Music Hall reverberated with the sounds of previously locked doors slamming shut, sometimes with such force that the frames were splintered. Students practicing late into the night were unnerved by odd lights floating in the halls, and on more than one occasion, indistinct figures approached frightened musicians before disappearing just prior to contact. The proximity of Fort B, manned by Union troops almost a century before, led some to believe that the spirits in Brandt must be Civil War soldiers still walking their posts.

Much older specters seem to haunt Rose Theatre, down the sloping terraced hill from Brandt in nearby Grauel Hall. Built in 1966, the Forrest H. Rose Theatre housed the Theatre Department for many years, during which time it became the subject of some of Cape Girardeau's most enduring ghost stories. Despite its relatively brief history, the spooky legends surrounding the Rose are not altogether surprising considering that theaters are often associated with hauntings. Perhaps this is because the emotions acted out on stage and played out in audience members' minds have been left behind. Or maybe it has something to do with the material decay and social obsolescence of a once vibrant entertainment venue now replaced by soulless multiplexes. (Rose Theatre has been effectively vacant since the department moved

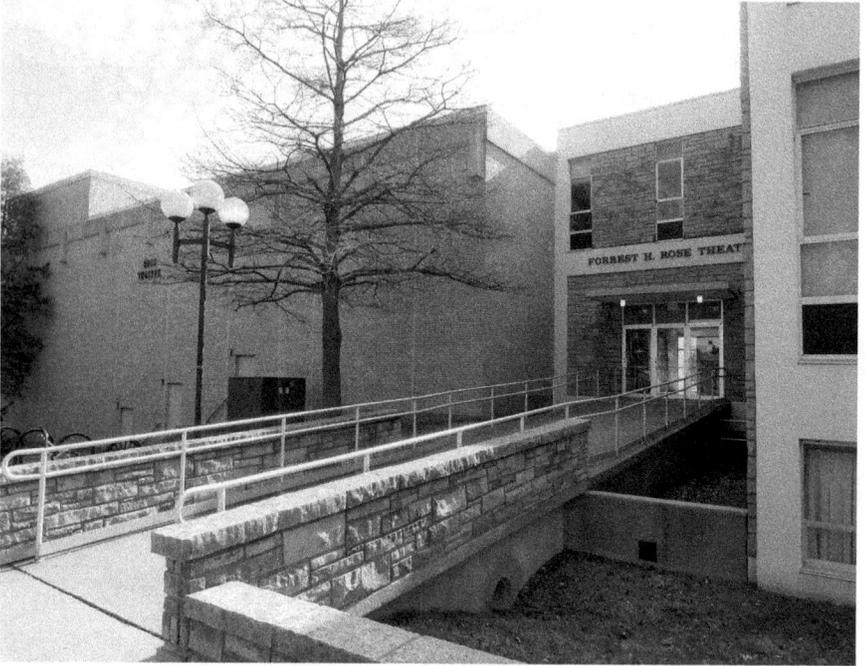

The Forrest H. Rose Theatre on the campus of Southeast Missouri State University. *Photograph by Jeanie Rhodes.*

to its new performing arts center at the River Campus.) Whatever the reason, theaters are rife with ghostly folklore and persistent superstitions among actors and actresses. Seats are routinely left available for ghosts during performances, and it is considered rather risky to even mention a spirit by name while on stage for fear it will manifest.

For generations of performing arts students who called Rose Theatre home, unsettling stories about a wraithlike lady, mysterious blood stain and shadowy old man were just a part of life on the stage. Christy Mershon, assistant director of Extended and Continuing Education at the university, is well versed in the haunted nature of the theater:

> *There's Mary, which is just a name students have given her…I think it comes from the old Bloody Mary stories. Mary was said to be a girl who was murdered on the land before the theatre was built. And there's a mysterious spot in the back row of the theatre said to be blood, and I've heard several variations of this, that when they poured the concrete*

that makes up the floor of Rose that the spot just appeared. No matter what they did, it just kept coming back out, and so it couldn't be rust, it had to be blood. And most of the Mary sightings are seen in that back row of the theatre where the blood spot is.

Interestingly, there are no clear answers about exactly who the ghostly Mary is or why her spirit is trapped in the auditorium. "Sometimes Mary is a young girl," Mershon points out, "and sometimes she's an older woman, probably a woman in her twenties or so. There are some stories that I think lean toward her being a childish ghost." In fact, many thespians tell of catching a glimpse of a little girl—whom they insist was killed on the property—sitting alone in the audience when the hall is completely empty or walking pensively down the aisles. One alumna remembers an experience with Mary while working late in the costume shop, which was located downstairs from the back of the stage. When she and her friends were turning off the lights and closing up for the night, their attention was cautiously drawn back down the dark stairwell, where they could hear the soft voices of children whispering from inside the locked costume shop. Nervously laughing and reassuring themselves that they must have simply forgotten to turn off the radio, one of them ventured back down to turn it off, only to sprint back up the stairs. Visibly shaken, she breathlessly explained that no radio had been left on in the still room.

Another actor recalls arriving quite early for rehearsal one night and falling asleep in the front row of the dark and deserted theater while he waited. Finding it difficult to stay comfortable in the rigid seats, he twisted back and forth, and while doing so, a movement caught his eye back up the aisle toward the entrance. Slowly, one by one, the dim theater lights that run the length of the aisle to illuminate the steps of the auditorium were obscured, as if an invisible someone, or something, was making its way toward him in the front row. Not waiting for its impending arrival, he leapt from his seat and escaped the theater using the other aisle where he finished waiting for rehearsals from the safety of the sidewalk.

Others speculate that Mary was actually the wife of a French fur trader during the raucous riverboat years of the early nineteenth century. The couple, it seems, shared a cabin on the ground where Rose Theatre stands today, but it was never a happy home due to the company that the amorous Frenchman was notorious for keeping at the

houses of ill repute along the levee. On one particularly lonely night, the distraught Mary determined that she would end his philandering ways once and for all with a violent act of retribution. After patiently waiting for her husband to make his way home through the woods from the river, she pounced on the drunkard, carving him up with the rusty and dull knife deliberately chosen for the pain it would surely inflict. As he slowly bled out in agony on the floor, Mary completed the grisly task of ending their miserable marriage by taking her own life as well, creating two pools of blood on the bare plank floor.

This older Mary is a far darker and more troubling spirit. When witnesses tell of her presence in the theater, the stories are of a much more active and volatile nature. Objects are moved about, sometimes violently, and sinister laughter that can make your blood run cold can be heard. It appears plays with violent themes—specifically murder—provoke her, as does the mere mention of her name from the stage. Her heinous deeds may also account for the indelible stain on the floor, a reddish pattern—allegedly determined by the science department to be at least a century old *and* human—that is still spreading out after all these years.

In the early 1980s, flickering lights in the dressing rooms panicked almost an entire cast after a production. Some still in costume, the actors were trying to keep their composure while getting dressed in the intermittent darkness when they all heard hammering noises coming from the walls. As the cacophony grew louder, sounding like banging on water pipes, they hastily escaped the theater in various stages of undress.

Almost a decade later, another cast in rehearsals witnessed a very noticeable cold spot on stage, and in their surprise someone broke the superstitious prohibition against mentioning Mary by name. Most tried to make light of the faux pas, but those well versed in the theater's folklore kept a wary eye out for anything mysterious. Later, after the run through, when the actors were taking notes, one did glance up toward the back of the house by the blood stain, where he saw a shadowy woman in a pinkish dress from the 1800s glaring down at them before vanishing.

Any doubts about the specter's identity were laid to rest on the opening night of a subsequent performance when the same student heard a loud commotion coming from just off stage a few hours before show time. No one was supposed to be backstage at the time, and so several inquisitive cast members bravely investigated. As they approached, they

could still hear someone walking heavily around behind the curtains. Ultimately they could find no one, and on further inquiry people in the box office confirmed that no one had been in the area since before lunch. Just then, the house lights flickered rapidly, and with a series of popping noises, the speakers and monitors from the sound system blew out. Frozen in silence, someone managed to mouth the name: Mary.

Even Christy Mershon has had her own personal encounter with Rose Theatre's resident lady. During one of her annual workshops for amateur ghost-hunters in Cape Girardeau, Christy joined an investigation of the theater already in progress. "I hadn't been in there with them the entire time," Christy recalled. "I walked into the back of Rose Theatre, and as I was heading down the stairs I got to about the third stair from the top, and I felt like somebody shocked me. My dad has a 1940s refrigerator that he's very attached to, and he's never gotten rid of it. But I learned at a young age that if your hands were even slightly damp and you touched the door of this refrigerator it would almost make the hair stand up on your head. It was a really similar feeling to that."

Under the assumption that someone in the group had played a prank on her, Christy suddenly came to the realization that everyone was taking pictures of her. "She's right beside you," whispered a psychic investigating with the workshop that year. But as Christy guardedly peeked over each shoulder, she never caught a glimpse of what was shocking her. Her companions finally motioned for her to walk slowly down the stairs toward them, and as she did cameras captured her descent. "When I got to the bottom of the stairs," Mershon remembered, "she [the psychic] said she had disappeared, and about the time she said that, I quit feeling that staticy [sic] feeling."

Eager to review the evidence, they all scrolled through their digital cameras, and sure enough, in every single photograph, a pinkish colored floating ball of light hovered right next to Christy. "If you've watched the sci-fi stuff, they call that an orb," she explained. "People had taken their photos from different locations and angles, and so the likelihood of its being like a reflection from the exit sign or something I would have thought would have been moderated a little bit by the angles that folks were taking the pictures. There wasn't any ambient light coming in from outside because that's a pretty sealed area."

For all of Mary's persistent notoriety, she apparently is not alone in haunting Rose Theatre. Many who have claimed a supernatural

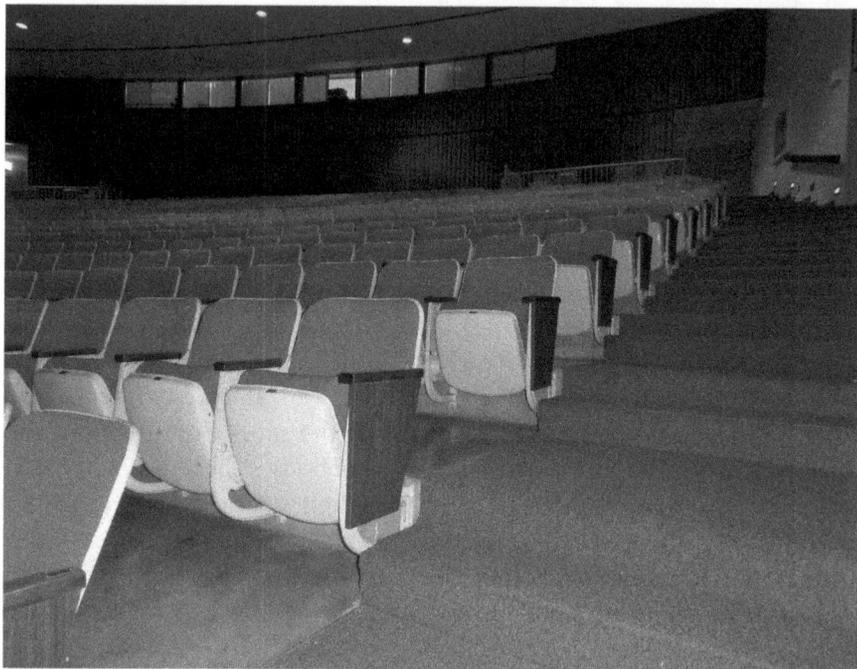

The eternally occupied Seat D28 in Rose Theater. *Photograph by Joel Rhodes.*

experience there are convinced they, in fact, encountered an old man sitting in the audience; the oddly drafty seat D28 to be precise. Curiously, the old gentleman never attends actual performances but prefers instead to take his entertainment from watching rehearsals in his favored place, four rows back on the theater's north side, where over the years he has caught the attention of many theater students, and vice versa. During one summer theater class, a student found herself alone in the Rose and upon climbing on stage to look for friends in the wings or scene shop, she noticed a single man seated in the house. Thinking it was perhaps the friend she had been looking for, the young theater major called out for him to wait. At that precise moment the old man simply disappeared before her eyes. Although convinced no one would believe her, she was surprised to find that not only did her friends not scoff at her story, but they also offered their own personal variations of similar occurrences, explaining that according to legend, the old man had at one time owned the land on which the theater was built and after

refusing to sell out to the university in life, now stubbornly refused to concede an inch in death.

A non-theater major revealed that while dating a young man in a past production, the two had quarreled on stage left one evening after his rehearsal. During the terse exchange, the actor grew suddenly pale as he abruptly dropped the conversation. At first the dramatic pause irritated the woman, but while her boyfriend stuttered to regain command of his words, she followed his gaze out into the vacant auditorium, where a spectral figure sat in row D near the aisle. Eerily, the elderly phantom paid them no mind initially, rather focusing his attention on center stage, as if captivated by the drama of a nonexistent performance. Very much aware that they were the only living souls in the house, neither student dared move for several minutes until finally the ghostly old man shifted slightly in his seat and stared directly at them. His demeanor changed—a stern look of disapproval replaced amusement—and both got the distinct impression that they were somehow being rebuked for rudely staring at him. And then he faded away. This was why, she explained, after swiftly leaving her erstwhile boyfriend and Rose Theatre behind, the young lady never set foot in 408 North Pacific Street again.

CHENEY HALL

If you head toward Academic Hall and take a right on Henderson Avenue, just a block or so from Rose Theatre, you'll find Cheney Hall, which houses its own bloody spirit. Built during the Great Depression, the university's oldest and smallest dormitory still retains much of its historical fabric with original oak woodwork and old-fashioned features such as fireplaces and open lounges not found in modern residence halls. Campus legend has it, however, that in one of Cheney's charming third-floor rooms a female student committed suicide in the 1970s. It was during finals, and as the weight of multiple exams and term papers bore heavily on her, pressure to maintain just the right GPA turned to despair. Overwhelmed, the co-ed locked herself in the lavatory of room 301 with a razor.

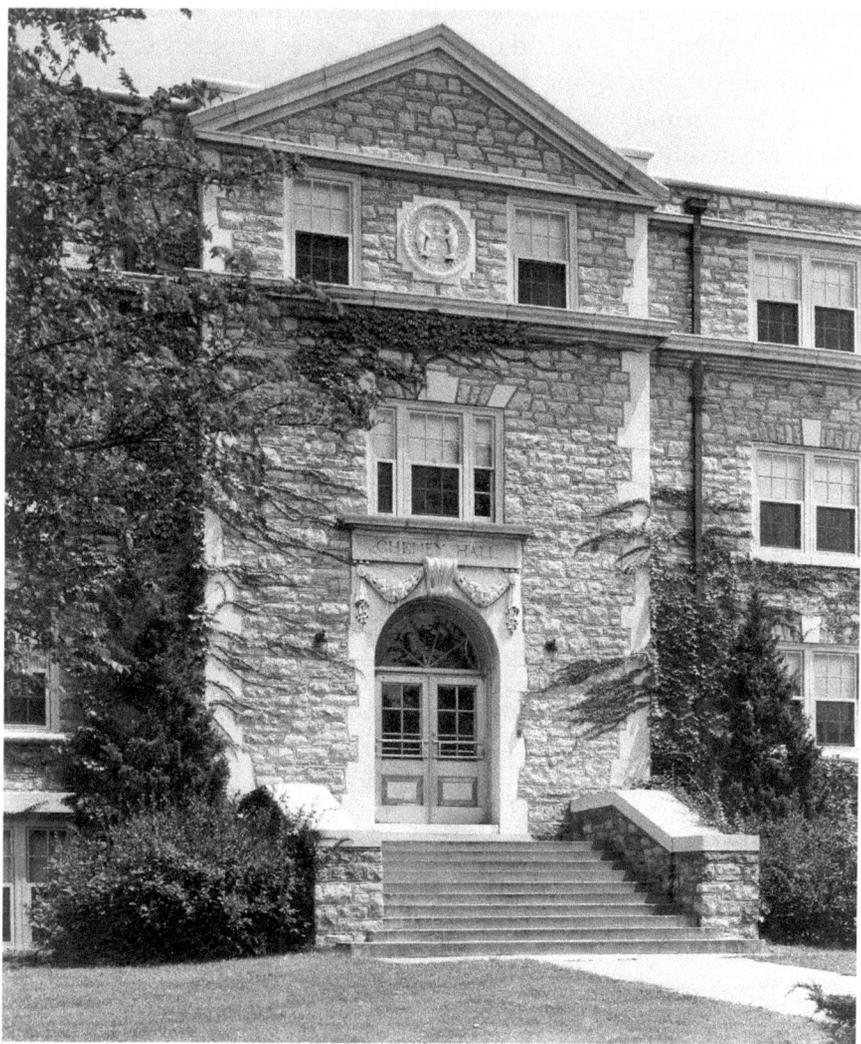

Cheney Hall, circa 1949. *Courtesy Southeast Missouri State University Special Collections and Archives.*

After authorities removed the body from the gruesome scene, facilities management crews worked diligently to clean up the bloody bathtub, to no avail. No matter how hard they scrubbed or what chemicals were used, the stained ceramic remained a deep crimson. So with a new semester fast approaching, and budget concerns precluding a replacement bathtub, workers hastily built a shelf around the tainted fixture, converting the bathroom into a storage closet. When students returned to Cheney for the next term, they immediately began complaining of mournful noises coming from room 301, often punctuated with a slamming door. Those out of their rooms after hours spoke of encountering a ghostlike young lady in a flowing white nightgown who aimlessly drifted through the third-floor halls. A few passersby on the Henderson Street sidewalk in front of Cheney also swore they saw a mysterious, pale girl peering out third-floor windows who would invariably turn away slowly and vanish.

One evening in 1975 (the dorm was co-ed by this time), a Cheney Hall resident inside the building chanced to see a shadowy lady gazing out the window on the stairwell landing. Thinking he recognized her, the student followed the young lady as she climbed the remaining stairs to the third floor in complete silence, eventually making her way down the hallway to room 301. Hoping to engage her in a bit of conversation, he knocked repeatedly on the dorm room he had just watched her enter, but no one ever answered. The next day, when he actually did run into the girl who occupied 301, she apologized for the perceived slight, explaining that she and her one roommate had both been off-campus the entire night before.

Within just the last few years, a student heard residents telling of Cheney's hauntings at a holiday party; the stories called to mind his own odd memories. He recalled that several semesters prior, he had furtively spent the night with his then-girlfriend in her Cheney Hall room. With a normally disapproving roommate gone back home over the weekend, it was turning out to be an excellent evening until he awoke in the wee hours of the morning with the darkened figure of a woman standing over his sleeping girlfriend. In the soft campus streetlight, which slightly illuminated the room from behind the form, he could just make out a blurry silhouette with dark, wavy hair, and although he could not see the face distinctly, he assumed naturally that the roommate had unexpectedly come back early. Hoping to avoid a judgmental confrontation, he quietly rose, offered a half-hearted

apology and began getting dressed to leave. All the while, the woman watched him and his still sleeping girlfriend. Only after his shoes were on did she finally turn and drift gently back to the roommate's bed by the window. But while leaning over to kiss his lady friend goodbye, he noticed that they were once again alone in the tiny room.

Considering that the relationship had ended soon thereafter, he always figured that the strange experience had been nothing more than the remnants of a dream. That was until he heard these perplexing stories of Cheney's otherworldly resident. Where in Cheney Hall had his old girlfriend's room been, the other students wanted to know. Third floor on the north side, he recollected. But did he remember exactly which room? Room 301, he thought.

PI KAPPA ALPHA FRATERNITY LODGE

Although the men of Pi Kappa Alpha fraternity reside among the other Greek houses on campus, since 1973, they have maintained a sort of annex on South Sprigg Street for various chapter business and social functions. This Pi Kappa Alpha Memorial Lodge, which is usually known for brotherhood and much frivolity, also happens to be one of the most notorious haunted houses in Cape Girardeau, inhabited by a ghostly schoolgirl named Jessica. Her story begins nearly a century ago, long before the Pikes (as they are known) arrived in this part of town, historically called Smelterville. The southern areas of river towns are generally some of the more economically depressed, primarily because the Mississippi gently drops about nine inches per mile as it heads toward the Gulf, leaving neighborhoods farther downstream more vulnerable to flooding, thus lowering property values and discouraging business. The substantial Marquette Cement plant dominated Smelterville, and in 1924, the company built a two-story schoolhouse to serve the children in the surrounding Rock Levee rural school district. Little Jessica, no more than eight or nine years old, attended this Marquette School.

According to local folklore, Jessica also died tragically in the Marquette School. During the final recess on a Friday afternoon, Jessica apparently left the crowded playground to quietly jump rope indoors. Because

the principal had gone home early, she found her way into his office (today the Pike chapter room). While jumping there alone, a rickety floorboard gave way, and Jessica tumbled into the boiler room below. When the students were dismissed for the weekend after playtime, the last teacher walked through the school to lock up and, remembering that the principal was already gone, did not open his closed office door. She assumed all the students, including Jessica, were headed home, and hearing nothing to the contrary, she closed up and left for the weekend.

Fearing the absolute worst when Jessica did not come home, her family frantically searched for their daughter over the next two long days. But on Monday morning, when the principal discovered the splintered hole in the corner of his office floor, the mystery was finally solved. Firemen summoned to the increasingly panicky scene chopped their way into the coal chute near the boiler, and indeed, there was a tiny body blackened with coal dust and soot. Doctors later speculated that Jessica had been knocked unconscious when she fell and could not scream for help as the teacher locked up. An autopsy later showed her lungs to be filled with black coal dust, suggesting that she survived the initial fall only to suffocate sometime over the weekend during a desperate and, ultimately futile, fight to climb out of the coal chute.

The pall of Jessica's heartbreaking death never lifted from the school, and after the institution eventually closed due to consolidation, years of vacancy and neglect only fueled community suspicion that Jessica's spirit still haunted her old classrooms. Motorists on South Sprigg Street after dark talked of seeing a lonely little girl skipping rope by herself in the abandoned playground while others swore that when the moon was just right, you could make out a pale face gazing out a classroom window at passing trains nearby.

After the destructive 1973 flood, when most structures in Smelterville were either bought out or removed, the Pi Kappa Alpha chapter at Southeast Missouri State University purchased the old school and converted it into their lodge. Soon they, too, became acquainted with the ghost confined within the walls. As fraternity members have come and gone over the last forty years, their experiences with Jessica have remained fairly consistent. She is a shy presence, reluctant to manifest for crowds, but individuals and small gatherings sometimes hear her playing. From the coal chute that entombed her, the faint echoes of a bouncing ball and innocent childish giggling still unsettle even those accustomed to her antics, as does the tiny voice singing jump rope

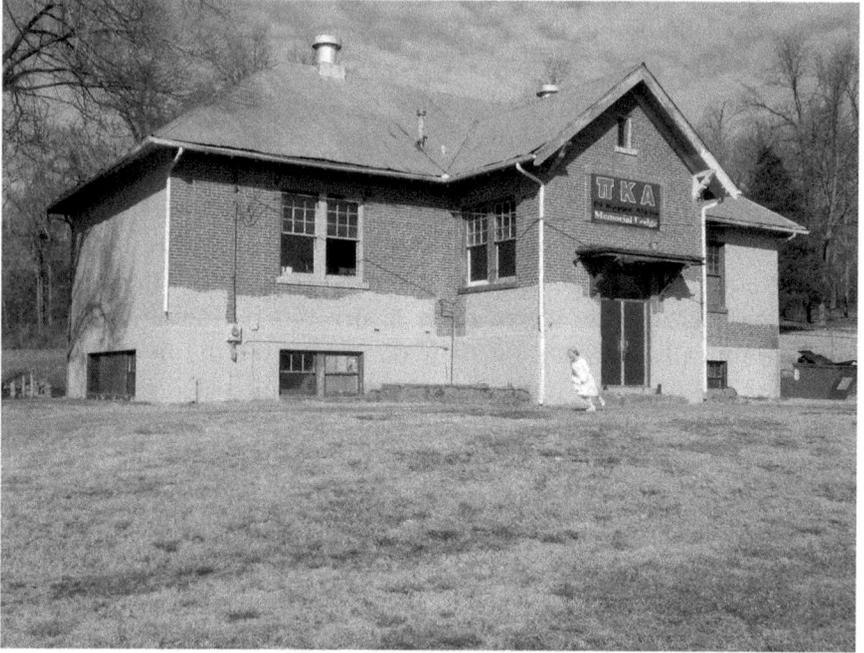

The ghost of little Jessica is said to haunt her old playground around the Pi Kappa Alpha Fraternity Lodge. *Photograph by Jeanie Rhodes.*

rhymes that can be heard in sync with the gentle skipping of unseen feet on the old boiler room floor below.

Sometimes, though, Jessica can be a bit more mischievous. Strange, unfamiliar noises greet visitors, and odd, rhythmic rapping emanates from the walls. Light fixtures sway back and forth. Windows softly vibrate before opening and closing by themselves, as do doors. On one rare occasion, she brusquely pulled the plug on a boisterous Pike party by bewitching the sound system. In the middle of the revelries, the lights in the Pike Lodge suddenly went out, and although the stereo remained on, the speakers fell silent. After a few nervous minutes, during which time the brothers determined that technical problems were not to blame, the lodge was once again illuminated and the music restored.

Researchers from the St. Louis–area Paranormal Task Force investigating the Pike Lodge in October 2007 recorded traveling cold spots and unaccounted for electromagnetic frequency (EMF) spikes. Documented interaction with an entity through Yes and No questioning

led investigators to the conclusion that another lonely spirit besides Jessica stays in the lodge, a ghost that appears to be male and is perhaps a departed member of Pi Kappa Alpha. Likewise, audio recordings picked up a number of vocal sounds, ultimately leading the team to a fateful conclusion. "It is the opinion of Paranormal Task Force," their report states, "that even with just this mini-investigation which captured two remarkable EVP's or disembodied voices coupled with the wealth of the unexplainable interaction of something with the EMF meters is enough to substantiate an actual haunting and the existence of paranormal activity…at this location."

But the Pikes and their guests have known that for some time. Ask any of them, and they will probably tell you about the little neighborhood boy who showed up during a chapter meeting once, asking permission to play in the house during those times when they were gone. After they explained the danger and liability issues that made them regretfully decline his request, the disappointed boy protested, countering that he really enjoyed playing in and around the old school. You see, he had befriended the little girl who lived there.

ALPHA KAPPA PSI FRATERNITY

Back on Southeast's main campus, within eyesight of Rose Theatre and Cheney Hall, another haunted fraternity house has offered its residents even more hair-raising encounters. When the members of Alpha Kappa Psi moved into the stately Colonial Revival–style home at 730 North Pacific Street in 1973, they brought with them only a vague awareness of its history. The nearly one-hundred-year-old structure, the fellows understood, had been built by a very prominent Cape Girardeau family who carefully and affectionately tended to their beautiful home and sprawling estate throughout its long history. Only after the patriarch's death had the house on Normal Hill passed by bequest from the family's ownership to the university.

Even though they noticed peculiar sounds and unnatural occurrences almost immediately after moving in, nonetheless, few of the men were initially willing to entertain the notion that anything more was at work

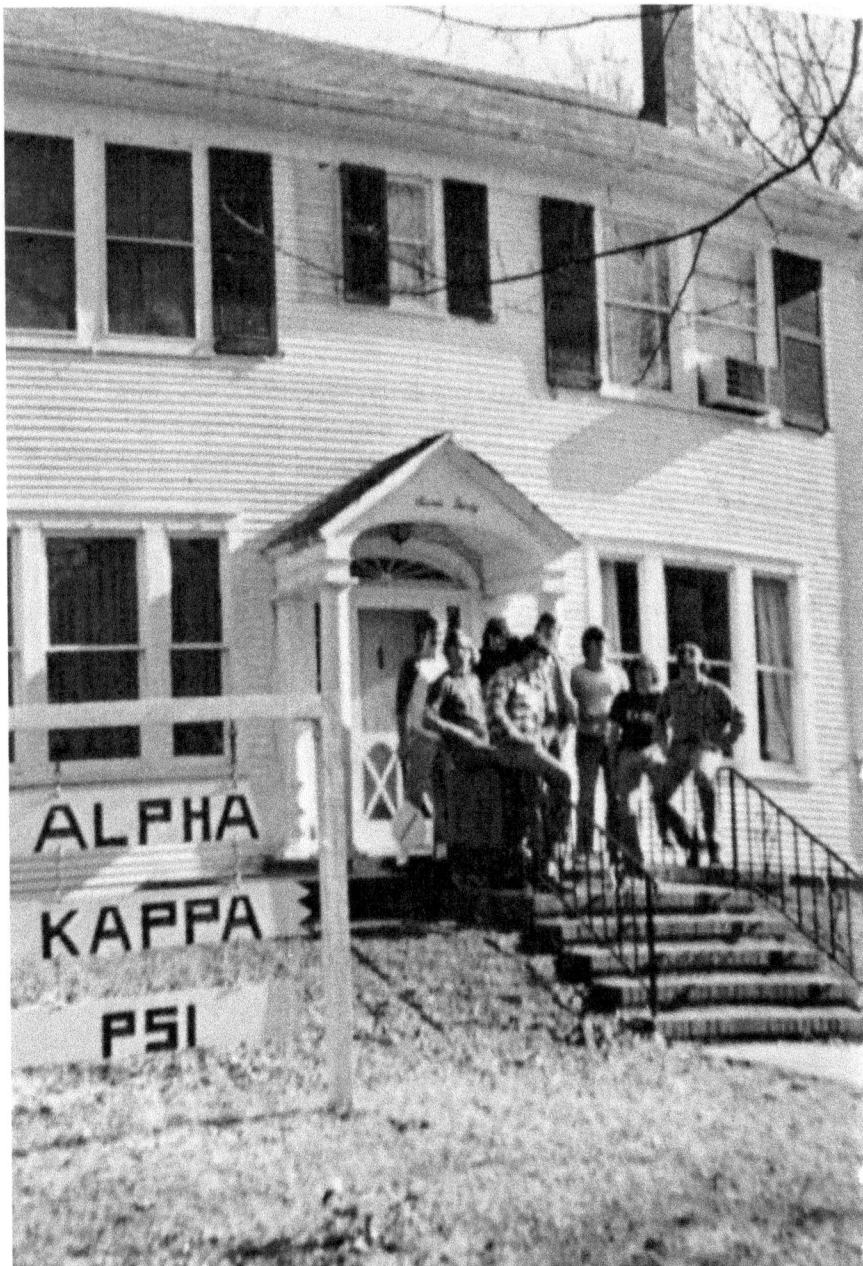

The Alpha Kappa Psi Fraternity as pictured in the 1976 edition of the Southeast Missouri State University yearbook, *Sagamore. Courtesy Southeast Missouri State University Special Collections and Archives.*

than just the quaint creaks and groans of a distinguished older home. Soon, however, the oddities became too frequent and creepy for rational explanations. And no one seemed immune. Hours of weary homework would sometimes be interrupted by unseen hands periodically opening and closing the door to their study room as if someone had come by to check in on their academic progress. Jovial laughter softly resounding from the cellar raised eyebrows on occasion, just as monotonous pacing in the attic kept others awake at night. In one of the old bedrooms, even when there was no one else in the house, students claimed to hear low moaning, which to their ears sounded as though it were caused by physical suffering. One of the secluded spaces in the basement converted to a bedroom became notorious for phantom knocking on the door at all hours of the day. Try as he might, whoever was living in the cellar bedroom could never get to the door fast enough to lay eyes on the visitor, even if he waited patiently behind the door for hours to quickly swing it open. The rickety staircase to the basement, which strained under the slightest weight, never so much as squeaked before or after the knocks, leading those alone in the remote bedroom to the ominous conclusion that the knocker must by staying in the basement with them.

Every so often, the members of Alpha Kappa Psi got the distinct impression that the house might be disgruntled by their unfamiliar routines and personal possessions. One winter morning, after going to bed under two very warm blankets, a young man awoke absolutely freezing. One of his comfy blankets was neatly folded on the nearby dresser and the other thrown nearly across the room. A number of students have found their untidy desks rearranged for better efficiency while others with a chronically disorganized workspace have been startled out of bed by the clamor of everything on the desktop being rudely thrown onto the floor. In one peculiar room, windows simply remain open year round despite consistent efforts to close and lock them multiple times each day. Even when roommates locked the windows before bedtime and tried to keep watch all night long, the next morning they were invariably back open.

It also seemed that when someone entered the house alone they could distinctly hear footsteps walking from room to room in the upstairs floors, including the unusually small closet too cramped for a person to stand upright. A former member recalled one such chilling experience that finally convinced him they were living in a real-life

haunted house. On this particular night, he and the others of Alpha Kappa Psi had been away all evening at a party when he returned unannounced to their empty fraternity to retrieve some forgotten item. Because he was in a hurry to get back to the festivities, he never bothered to turn on the lights as he bounded quickly up the stairs toward his second-story room. There in the dark hallway, he heard footsteps coming from the attic above. Instinctively, he hollered out to see which of his friends might have been left behind that evening. No response came, nor did the footsteps so much as pause. In a rush of adrenaline, he finally turned on the lights and rushed up the remaining stairs to the attic. He was alone on the top floor, but now the footsteps resumed two levels below him, on the first floor. He wanted to believe that another brother had since come home, so he raced downstairs only to discover he was still by himself. Then the footsteps began again, back up in the attic, to which the only access was the stairway he had just breathlessly descended. Those same footsteps were still in his ears as he sprinted out the front door.

It seems similar circumstances soon led the fraternity to seek a professional opinion. When a different student returned to a dark and empty house on another occasion, he also heard the footsteps. Yet during his frantic investigations, he happened on a figure seated in an overstuffed chair in the living room. Taking a moment to compose himself and let his eyes adjust to the blackness, he slowly made out the shape of man who, in the absence of any light in the room, appeared to be dimly glowing. Momentarily frozen by the sight of the apparition, at some point he spun around and hastily retreated from the home. Soon thereafter, the men of Alpha Kappa Psi contacted a clairvoyant considered at the time to be among the country's top paranormal investigators.

On Halloween 1983, Ed and Lorraine Warren wrapped up their regularly scheduled lecture on the occult and paranormal at the university and accepted the fraternity's invitation to tour 730 North Pacific Street. In a forty-five-minute, room-by-room investigation, without any background information beforehand, Lorraine Warren made frequent contact with an entity she described as "a distinguished-looking stocky man with a full head of gray hair." His presence felt stronger in some areas, especially the study room, she thought because "apparently he was most comfortable in his study." Warren got little feeling from the family room or dining room, perhaps, she speculated

because the old gentleman "may have had trouble communicating with his family."

"He seems like he was separated from his family, but I get strong feelings here in what must have been his study," she reported to the members. In the master bedroom, the psychic "felt" him most intensely, yet the sensations were different. "In here, though," she told them, "I sense a raspy cough like he may have suffered repository problems. I also feel pressure in his body. It affects the head, the whole head, there is a great deal of pain."

With their ghostly suspicions confirmed, the fraternity members revealed to the Warrens the results of their own research. The house, they had discovered, once belonged to a very distinguished man indeed, Robert Burett Oliver Jr. Like his renowned state senator father, the younger R.B. Oliver (as both were known) was an extremely successful and well-respected local attorney. Their firm of Oliver and Oliver, which also included brother Allen, counseled many of southeast Missouri's most high-profile clients, including the Little River Drainage District. His mother, Marie, actually designed and crafted the Missouri state flag during the first decade of the twentieth century in her home just a few blocks away. Along with the Limbaughs, the Olivers were considered the region's foremost legal family. The junior Oliver had built this house and lived virtually his entire life there, dying in the summer of 1971 from a blood clot in the head at the age of ninety.

R.B. Oliver Jr., they felt certain now, was their ghost, and they asked the Warrens for advice about how to deal with the spirit they had come to respectfully refer to as the Judge. On one hand, Lorraine Warren hesitated to classify the Judge as earthbound. Rather, she thought "the chances are his visits are seasonal, perhaps the anniversary of his death manifests him." However, she believed even these visits were troublesome and admonished the fraternity to sever his connection to the house. "You do want to remove the old Judge," Warren concluded, "because as long as his spirit is here he can't move on and also he is drawing energy from all of you in the house. He is staying here because he has a great attachment to this house and that attachment must be broken." The first step she proscribed involved having the house blessed by a chaplain.

How successful the men of Alpha Kappa Psi were in helping the Judge move on is debatable, depending on whom you talk to. Regardless, within a short time, the fraternity vacated the premises,

and the university abruptly demolished the handsome home at 730 North Pacific Street, curiously on a Saturday morning when no one was around. A tranquil mediation garden now marks the spot of the old Oliver mansion.

While every new class of freshmen invokes some variation of these traditional campus hauntings, the next generation of unexplainable phenomenon at Southeast Missouri State University may already be taking root at the River Campus. Housed in the antebellum St. Vincent's Seminary, the modern performing arts center inherited many legends from its days as a school for young men. Chief among these is "Old Henry" King, the freed slave who died in the devastating tornado of 1850 while working as St. Vincent's hired hand. Throughout the nineteenth and twentieth centuries, seminarians told of seeing and hearing Old Henry in the chapel and auditorium, faithfully caring for the sacred edifice. Others claimed to have come face to face with a bent spirit working on the grounds where Old Henry's small cabin collapsed on him in that horrible storm and where, legend has it, he is buried.

The closing of the seminary in 1979 temporarily silenced Old Henry, although amateur ghost hunters continued to venture into the vacant structure periodically hoping for a glimpse. Yet the commotion of renovation and bustling resumption of student activities seems to have awakened Old Henry and perhaps others. Once again, tools in the Art Department are turning up in rooms where they should not be, objects in the museum are invisibly adjusted and theater majors are reporting shadowy figures roaming the more than 150-year-old halls.

OLD TOWN CAPE

Many of the landmarks that define the look of historic downtown Cape Girardeau face the river as a testament to the Mississippi's central role in the town's founding and its commercial and physical fortunes since. Some of Warehouse Row along the riverfront remains from those days of regular steamboat traffic, when small mountains of farmers' produce and local merchants' products covered the levee. As the business district pushed out rapidly from these warehouses after the Civil War—running parallel to the river along Main and Water Streets—a healthy array of businesses complemented the river trade: mills, hardware stores, bakeries and confectionary shops, blacksmiths, harness makers, breweries, cobblers, tobacco merchants, cigar makers, furniture stores, haberdashers, barbershops, grocers, saloons, mercantiles and small factories. And in the first third of the twentieth century, much of the modern commercial and residential architecture in Old Town Cape completed the landscape of what may well have been the inspiration for Mark Twain's description of the fictitious Dawson's Landing, a town one day south of St. Louis, in his book *Pudd'nhead Wilson*.

Business ventures occupying the historic storefronts, banks and public buildings have changed over the years, in most cases to the point

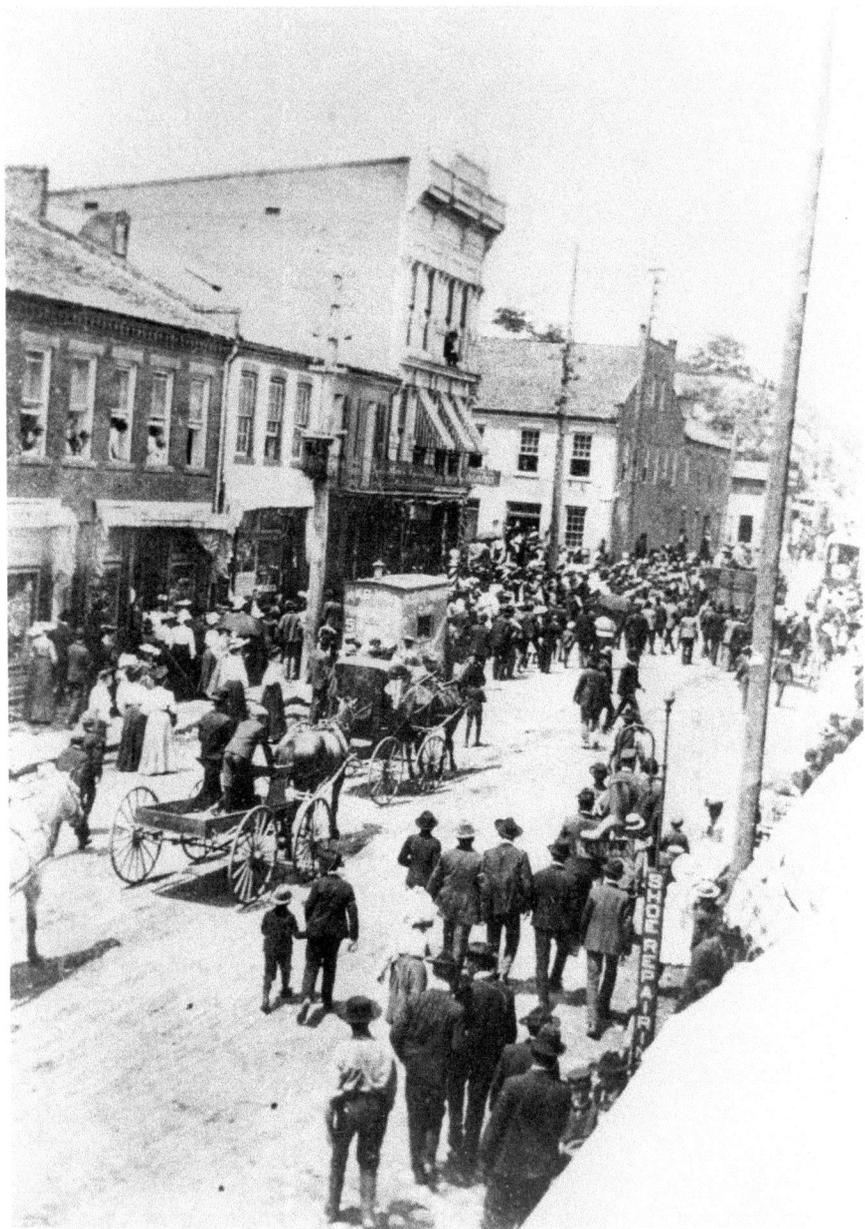

Much of downtown Cape Girardeau's modern commercial architecture was built during the first quarter of the twentieth century. *Courtesy Southeast Missouri State University Special Collections and Archives.*

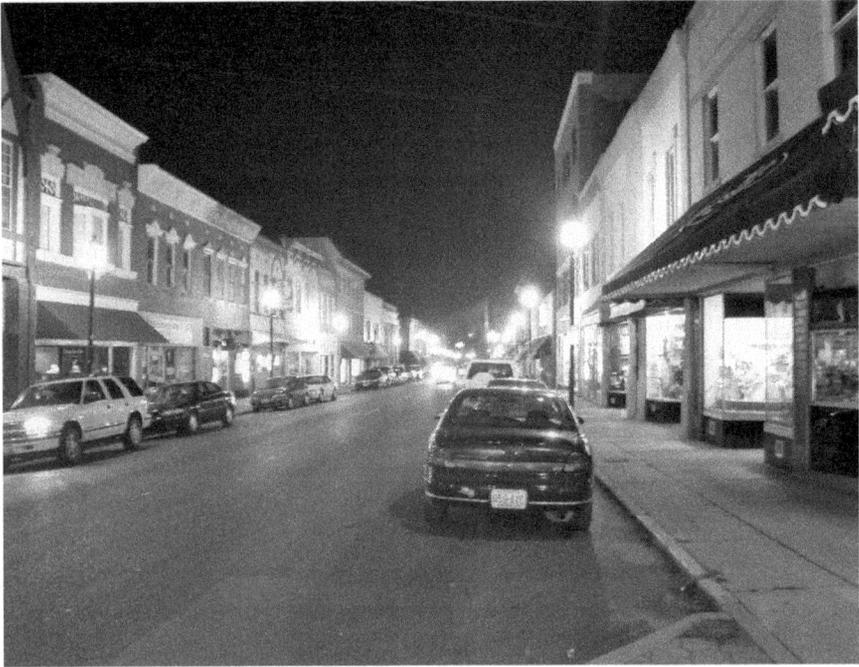

Main Street, Cape Girardeau on a weekend night. The lighted Bill Emerson Memorial Bridge is in the background. *Courtesy Cape Girardeau Convention and Visitors' Bureau.*

where one can no longer keep count, yet the ghost stories persist. Visit virtually any boutique, coffee shop or restaurant in the older blocks of the district and you may hear their unique tales of phantom customers or otherworldly tenants. Sometimes, these ghost stories have been known to play out before an unsuspecting patron's very eyes. The next pages offer but three tantalizing tastes.

Port Cape Girardeau Restaurant and Lounge

Anchoring the Warehouse Row Historic District (which is listed on the National Register of Historic Places), the Port Cape Girardeau

Restaurant and Lounge is one of the oldest buildings in Cape Girardeau. Built sometime in the 1860s, the three-story, red-brick structure—with arched windows and iconic 1920s-era, hand-painted Coca-Cola advertisements—has operated variously as a warehouse, commission house, packet company, hotel and, some would whisper, brothel or speakeasy during Prohibition. Most in town, though, recognize it in its modern configuration, as Port Cape, a renowned restaurant owned by Dean "Doc" Cain.

With so much history and legend surrounding the storied structure at the corner of Water and Themis, which include cherished but apocryphal tales of the Underground Railroad and Ulysses S. Grant, not surprisingly Port Cape is home to one of the most well-known ghosts in town. Her name is Belle, and those familiar with the building's odd creeks and moans, especially the unexplainable late night sounds heard when working alone, believe she has haunted the old warehouse for decades.

Perhaps no one can attest to Belle's presence better than Dale Pruett, a bartender at Port Cape for over twenty years and the man who has spent so many evenings with the spirit that he actually gave her that name. When he first came to Port Cape, the building was already an acknowledged haunting, and most every bartender, manager and waiter could relate at least one sighting or experience. Many had heard things, often in the form of noises in the empty halls or water running in unattended sinks. Even owner Doc Cain admitted to finding lights turned back on that he undoubtedly had switched off moments before or bulbs inexplicably unscrewed in their sockets. The existence of a very active ghost was just an unwritten part of the restaurant's culture.

At first, Dale described himself as ambivalent about the ghost of Port Cape. "I toyed with the notion of a haunting initially," he recalls, "you know, [a] 'yeah, why not'–type thing." But with each passing day, his suspicions of the supernatural were gradually confirmed, so much so that he grew tired of attributing peculiar happenings generically to "the ghost." Because they were going to be together for a long while, he thought she might as well have a proper name to go by. A few days after coming up with Belle, Dale remembers how it stuck. "I was out in the hallway downstairs, and nobody was in the bar area," he says, "And we have a bell…a nautical bell…and it just suddenly rang. Not just a little bit, not just a 'ting,' but really hard. I wasn't in the room, so I came back and looked, and the hammer was hanging there on the leather strap, and I just thought, 'Well, I guess she likes her name.'"

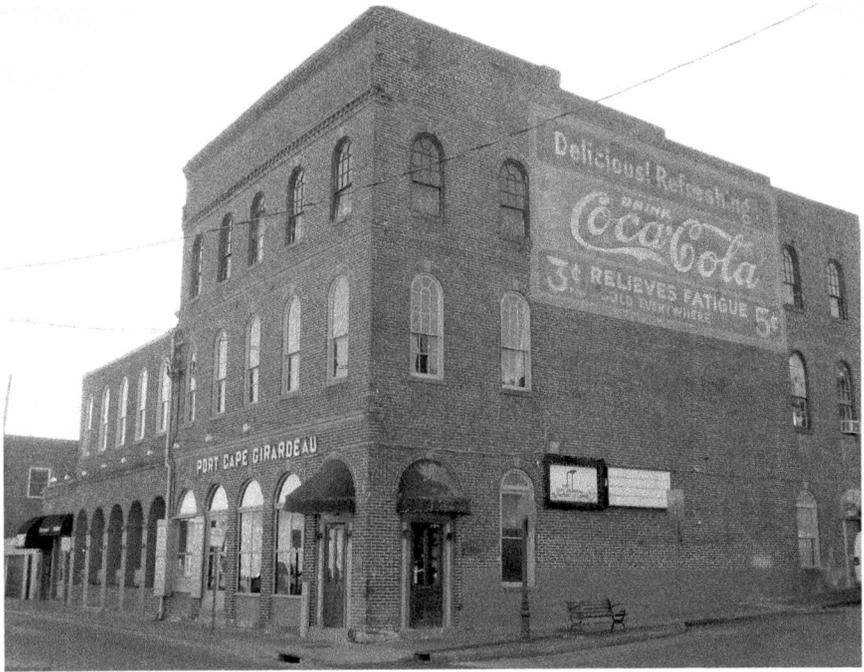

Port Cape Girardeau Restaurant and Lounge in the Warehouse Row Historic District is listed on the National Register of Historic Places. *Photograph by Jeanie Rhodes.*

That the phantom is female and has some maritime connection makes sense. A persistent part of the folklore identifies the specter as none other than the mistress of General Grant, who supposedly headquartered here very briefly in 1863 during the Civil War. Apparently, Grant took a Cape Girardeau mistress, and upon his abrupt departure to assume command of the Union army, the distraught young lady flung herself from a second-story window. A far more historically plausible origin for Belle lies with the Mississippi. She could be the wife of a daring riverboat pilot still vainly waiting for him to return from some forgotten and unspeakable steamer tragedy. Or perhaps she is the scorned and suicidal paramour of celebrated riverboat Captain William "Buck" Leyhe, whose Eagle Packet Company occupied the building around the turn of the twentieth century. Interestingly, during Leyhe's scandalous divorce in 1913, his estranged wife, Mary Filburn, did, in fact, paint him as a villainous old philanderer in the newspapers, which may

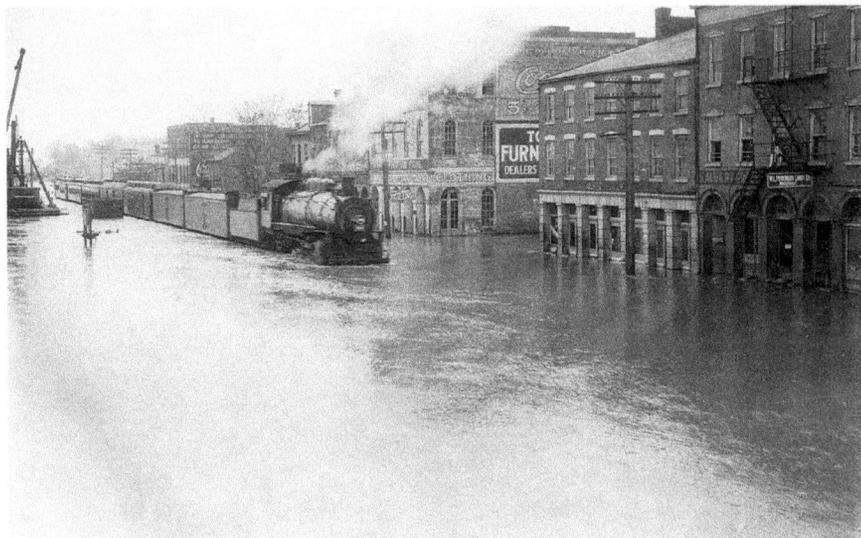

The raw power and destructiveness of the Mississippi River has historically wreaked havoc on those living in its path. The building, which is today Port Cape on Water Street, with its recognizable Coca-Cola signage, is to the right of the locomotive. *Courtesy Southeast Missouri State University Special Collections and Archives.*

account for why she was granted ownership of Warehouse Row in a very uncommon settlement.

Whatever sordid series of events may account for Belle's attachment to Port Cape, her behavior there remains fairly consistent. Most times, she makes herself known with "just little annoying things," according to Dale. "Noises. Footsteps. And there's nobody there. You'll check it out, of course, because you don't know. I just want to make sure it's not a hard body—those would bother me…You know, feel her hand on your shoulder…you know those things are kind of spooky."

"She's kind of playful," Dale also maintains, recalling one instance at the end of the day in particular. "I was doing the checkout one evening, and every time I'd do my paperwork, my peripherals would go wild. I'm in there all alone. So I slapped my hand on the table and said, 'If you'll just be quiet and leave me alone for a minute, I'll be gone.' And it went away. Then after about twenty more minutes of paperwork, I left. Sounds like you could come up with a scenario for all of this—light off the river, or mirrors or something—but no, that isn't what it was."

"She comes and goes when she wants. I'm on the clock, and she isn't," he explains of their frequent encounters. So, at the end of the evening, he often closes up shop by telling her out loud, "I'll leave you alone—I'm leaving. You can stay here all you want."

For all the times Belle has manifested for Dale and other employees, actual sightings of her are quite elusive. Few claim to have glimpsed her closely, but when they have, she has been a shadowy, almost incomplete figure floating along in a long, flowing, nineteenth-century-period dress. And she never appears for very long, always gliding effortlessly from room to room, and hall to hall, before disappearing altogether. Even Dale has never really gotten a good look at her. "What I have seen up here, as far as seeing things," he says, "they look like…orbs, I guess…floating across the room." In one unsettling case, Dale remembers a trip to the creepy storage area on the dimly lit top floor, where an ancient wooden freight elevator—one of the first elevators in Cape Girardeau—sits abandoned, and old furniture rests covered by dusty sheets and pieces of plastic. "Of course, they [the orbs] were heading to the same stairwell I was heading to myself," he points out with a sly smile. "Needless to say, with them ahead of me, I didn't run. I let them go ahead."

Visitors are usually the most eager to share their sightings with the bartender. "If somebody says they think they saw the ghost—Belle—they'll tell me a story," says Dale, and he is the first to confirm whether "they saw Belle." About fifteen years ago, he remembers, a couple from Wisconsin stayed in one of Port Cape's furnished rooms for the weekend, during which time they actually captured the visually shy ghost on film. According to Dale, "they just loved the room downstairs. There was nobody in there, so they took a picture from one wall looking at the other—north looking south, east looking west, that kind of thing—and he sent back some pictures. At that time, we had antique tables and chairs in that room. There were the same white orbs in three of the chairs in every picture. It was just orbs in a chair—the same three in all the pictures."

Pictures like this beg the question: is Belle the only ghost in Port Cape? Dale cannot be entirely sure. "There are probably others," he concedes, "and I assume that there are." He theorizes that maybe a number of entities take turns manifesting themselves, knowing that in the end the living will blame any misbehavior on Belle. The majority of new employees, and even a few seasoned bar and restaurant staff, do not

find this reasoning very comforting, especially considering that meeting Belle and the others has become almost a rite of passage for employees at Port Cape. "Most of the new people that are here aren't on friendly terms [with the spirit world]," Dale has come to understand. He can usually tell immediately who is comfortable and who is not simply by asking them to go upstairs and retrieve something alone. Even grown men, Dale chuckles, have told him over the years, "I'm not going upstairs. Not unless someone goes with me."

Coincidently, or not, workers believe Port Cape is more active now than ever before. Banquet servers report noticing something that resembles floating glitter around the exits on the second floor. Entire racks of glasses have been hurled off tables, landing dangerously close to co-workers, and of course, there are the ubiquitous footsteps moving about on the otherwise empty third floor. Just recently, around Halloween, a bartender delayed locking up because he believed a tipsy customer had remained behind in the ladies' room after closing time. Unwilling to enter for propriety's sake, his frequent knocks and admonishments went unheeded, but he could clearly hear, nonetheless, the stall doors opening and shutting along with the water faucets periodically turning on and off. Finally, after summoning a female to check inside, they were startled to find the facility completely empty despite having watched the door the entire time.

For stories like these, Dale will tell you, "I just hope it's Belle." The two, you see, have developed an understanding. When asked about the nature of their peaceful coexistence, Dale replies, "We're friends. Yeah." Yet on second thought, he qualifies, "Well, I don't know about friends," but he trusts that Belle likes him well enough. "I wasn't really sure in the beginning," he says. "But now we have to like each other. I'm not going anywhere, and she isn't, either."

To skeptics, Dale says that nothing substitutes for experience and that all it takes is living with a ghost to change your mind. When you see a stapler moving along the bar by itself for the first time, "you just blow it off, you know," Dale explains, maybe convincing yourself that "I didn't see that…And then it's like, gosh…it's happening more often."

"I had somebody ask me," Dale said, "What would you tell somebody that didn't believe in ghosts? I said, 'Move into a haunted house.'"

HECHT'S DEPARTMENT STORE

For most of the twentieth century, the upscale Hecht's Department Store anchored downtown Cape Girardeau. Opened in 1917 by second-generation clothier Louis Hecht, the ornate and eclectic Spanish Colonial Revival–style building at 107 North Main catered to the city's fashion conscious and stylish with excellent customer service and impeccable selections. Its broad awnings, elaborately painted open arched entrance and tasteful marble tile work heralded a big city shopping experience for small-town customers. Yet after an impressive eighty-six-year run, the Cape landmark, always owned and operated by the Hecht family, finally closed its glass doors for good in 2003. Prior to that, there is no mention of ghostly activity associated with this distinguished business. In fact, the fond recollections of customers usually center on women anxiously waiting for the new seasonal lines to arrive from New York and California or bored children struggling mightily to behave while mom shopped for what felt like days on end. No one remembers so much as a hint of the paranormal.

That changed rather dramatically in 2007 when the iconic structure reopened as Club Moxy. After sitting vacant for almost five years, the property needed a fair amount of remodeling to accommodate a nightclub, and during this work, the strange occurrences began. Very similar to a number of Old Town Cape businesses—most notably Buckner Brewing Company and Broussard's Cajun restaurant right across the street—there are those who believe the physical renovation disturbed something. Most of the initial construction work took place during daylight hours, which seemed to limit activity to minor annoyances: misplaced tools, rearranged work areas overnight and the like. Then the activity increased exponentially once the club opened in the summer, which may be explained by the increased number of people there after dark, particularly in the wee hours just after midnight.

It began when employees glimpsed spectral forms lingering among the shadows throughout the darkened first floor. Others heard footsteps, not in some far-off room or other level but within only a few feet, frighteningly too close for comfort. From the basement, amid the rusted hull of the decrepit furnace, the unmistakable clanking of heavy iron chains being dragged along the barren concrete floor sent a chilling tingle up the spine and quickened the step of wait staff already hurrying

The former Hecht's Department Store at 107 North Main Street anchored downtown Cape Girardeau for almost one hundred years. *Photograph by Jeanie Rhodes.*

to get out after closing time. More eerie still, workers, already spooked by the unexplained, started hearing the periodic cackle of laughing children from somewhere on the main level. One wide-eyed listener also made out the words, "Come play with us." And even when the establishment would completely empty out in the hours before dawn, security cameras would pick up orbs floating deliberately throughout the main level, some inexplicably splitting apart before coming back together again.

Unnatural images then began appearing on the second floor as well. A significant number of witnesses reported the same black shadows up there. These were not the normal two-dimensional kind but rather three-dimensional dark forms, roughly human size and capable of motion. Then there were the glowing eyes. Over the course of a few weeks, different employees encountered what looked to be fiery eyes piercing the darkness from unknowable faces. Before long, some simply refused to venture upstairs altogether.

The iconic Hecht's logo in the tile work of the department store's entrance. *Photograph by Jeanie Rhodes.*

Researchers from the Paranormal Task Force were summoned within just two months of the grand opening to determine the nature of what was haunting the old Hecht's Department Store. Their full investigation, including the use of passive and interactive techniques, was carried out over an October night between the most active hours of 11:00 p.m. till nearly 4:00 a.m. While never capturing the intense manifestations that had so recently troubled employees, the team did detect a number of traveling cold spots throughout the building and several mysterious EMF spikes. These electromagnetic frequency readings appeared to move and, in one exciting instance, seemed to interact through basic questioning. Other simple contacts that night yielded recordings of what sounds like audible whispers and various indeterminate noises. In due course, they concluded that their preliminary findings supported "a good probability of a haunting or the existence of paranormal activity" in Club Moxy.

However, before this could be substantiated, the club closed, and other businesses in Hecht's former location have continued to turn over

quickly. If anything, this only adds more flavor to those suspicions about the persistence of supernatural activity at 107 North Main. Like the other downtown establishments within a stone's throw, this may be only the creepy first chapter to one of Cape Girardeau's most recent hauntings.

CAPE RIVER HERITAGE MUSEUM

At the corner of Independence and Frederick Streets, the Cape River Heritage Museum preserves and interprets the heritage of southeast Missouri. With excellent exhibits on subjects ranging from the Cherokee Indians—who made their way through the region on the Trail of Tears—the era of the riverboats and the Missouri mule, the museum houses a number of historical artifacts and their accompanying stories. If you have ever had the opportunity to walk alone through a museum gallery or historical society after hours, especially the permanent collection storage area, you know the experience has a decidedly odd quality. After the visitors have left, there is something unmistakably spooky about being surrounded by the actual material of our ancestors' lives—how they ate, slept, worked, loved, recreated and died. In the dimly lit stillness, there is an eeriness to a one-hundred-year-old gown on a mannequin or a Victorian hair wreath that has nothing to do with *Night at the Museum*. This can be especially true when the building itself has a rich and colorful past.

Thus is the case of the Cape River Heritage Museum. Built in 1908, the building has at one time housed the city hall, fire department, police station and jail, along with a brief stint as the community theater. The cellar may be even older, perhaps dating to the antebellum years. And according to legend, the original structure it supported was commandeered by the Union for use as a prison during the Civil War, where the unfortunate souls suspected of loyalty to the Confederacy were chained to the underground stone walls.

Coincidently or not, the first recorded haunting took place when the old building temporarily served as the theater in the 1970s, after the police and firemen moved to more modern facilities. Cast and crew routinely heard what sounded like heavy male footsteps hurrying up

The old Fire Hall Number One at 538 Independence Street is today the home of the Cape River Heritage Museum. *Courtesy Southeast Missouri State University Special Collections and Archives.*

and down the stairs. Yet no such stairs even existed in that part of the structure. A bit of research later revealed that there actually had been a set of stairs, used frequently by firefighters, in the space's configuration during the building's time as a fire station.

When the museum took up residence in 1981, volunteers likewise heard the footfalls that by that time were widely understood to be on a phantom stairway. Sometimes docents were interrupted by deliberate knocking on the walls, which they naturally assumed were fellow volunteers trying to summon them to another room, only to realize uneasily that they had been alone in the museum all day long. Other times, workers in different parts of the facility simultaneously heard what sounded like a thundering herd of men rushing urgently through the building, a phenomenon they likened to the frenetic rush of firemen responding to some long-ago call. Doors often open and

close of their own accord, even those found to be securely locked. One visitor on official business recalled a meeting with former director Marge Thompson on a day when the museum was closed to the public. After letting him in, Thompson locked the door behind them, and the two walked down to the lower level of the museum, conversing as they went. Suddenly, they heard what was obviously the sounds of the front door opening and closing, and both glanced quickly back over their shoulders toward the entrance. Marge explained that very few people had keys, so they returned to the entrance to see who might be unexpectedly joining them. But the front door remained locked tight, and after checking everywhere, they concluded there was no one else to be found. The visitor, a doubter by nature, is unwilling to go so far as to say the place is haunted but still considers this spooky encounter his only personal ghost story.

Another former museum docent, Ann Abbott, told of a more ominous experience that started with disembodied noises and concluded with a rancid odor. On this particular evening, Abbott and another volunteer were investigating the origins of several unintelligible noises when they were confronted with the extremely powerful smell of turpentine. Struggling to breath, the two women diverted their search from the mysterious sounds toward a very real, and potentially flammable, turpentine spill they thought must be emanating from the area near the front office. As they searched in vain, Abbott began to suspect that her companion might be playing a practical joke on her, some type of paranormal-inspired snipe hunt. Yet as the volunteer denied any such thing, Abbott doubled over from a new, overwhelmingly vile stench. Oddly, even as Abbott became increasingly nauseated by the noxious smell, the other docent, standing directly next to her, could not initially detect it all. Within a few seconds, however, both were overcome by the horrible vapors. Making the scene even more surreal, the ephemeral smell confined itself to only those two women and to only the small area of the front office they occupied. No one else anywhere in the building ever detected it in the least, and when it left as suddenly as it came, no trace lingered.

In 2010, paranormal investigators sought out the Cape River Heritage Museum for an investigation because of its well-earned reputation for ghostly activity. Dan Bryant, a historic preservation student at Southeast Missouri State University, was interning at the museum at the time and accompanied the team during its evening

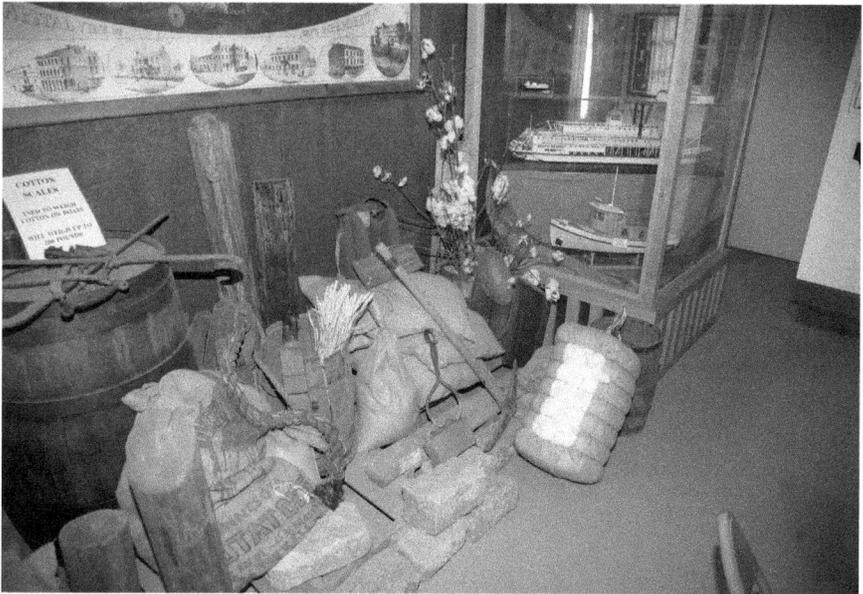

The Cape River Heritage Museum offers unique exhibits that interpret the rich history of the region. *Courtesy Cape Girardeau Convention and Visitors' Bureau.*

work. While attempting to make contact with yes-and-no questioning in an upstairs storage room where textiles and clothing are preserved, a spirit chose to manifest to Bryant. He described what at first felt to him like "heavy air" on his neck and shoulders. Over the course of several minutes, Bryant determined that the heaviness was similar to a hand resting, firmly but gently, near the collar of his shirt. Then it lifted. The other documented action involved an unlikely artifact. Over the course of the night, the investigators registered a significant number of random EMF spikes, but by far the most concentrated and frequent readings came near a historic popcorn machine, which is positioned toward the rear of the museum. This electromagnetic activity particularly puzzled the team because no one could ever remember the machine even being plugged in, let alone actually used. No explanation could be offered other than its location. The popcorn machine in question happened to be adjacent to the old fire truck on display.

Dan Bryant's lasting impression of working by himself in the museum is that anxious feeling that he was never really alone, not a threatening or menacing sensation but an awareness, nonetheless, that unseen

others were moving about and carrying on their own ethereal business. It was as if, he believes, those old policemen and firemen are still on duty, still following their old routines. "I think that they like that people are preserving their station," Bryant explained, and in some peculiar way "they are helping us guard it."

HAUNTED BYWAYS

Beyond the city limits of Cape Girardeau, a system of county roads penetrates the rolling and heavily wooded landscape that lies on the southeastern fringe of the Ozark Highlands. In a region that has been inhabited for so long, some of these modern roadways may trace a general path humans have followed for centuries. Cape Girardeau was, after all, one of five districts in the colonial Spanish territory of Upper Louisiana, along with St. Louis, St. Charles, Ste. Genevieve and New Madrid. Along older wildlife and Indian trails, early settlers established the first roads connecting those districts, calling them, collectively, *El Camino Real* or "King's Highway." Today, many towns along the Mississippi, including Cape Girardeau, preserve the tradition with streets and roads named "Kingshighway." Likewise, more modern cross-county, farm-to-market roads bisect the rural areas on the outskirts of Cape Girardeau, joining the thriving town to quite remote outposts in the countryside.

Over the years, a rich folklore of headless specters and phantom lights has developed alongside these secluded routes of dirt, gravel and asphalt. Perhaps it arises from the strange shadows of the crooked trees that form a dark canopy over some of the winding roads. Possibly it comes from the trepidation of venturing too far away from the comfort

of civilization, into the shadows of the unknown. Or maybe it can be better explained by the instinctive fear of being lost and vulnerable on a dusky, unfamiliar road that so many classic horror movies have helped to perpetuate. Then again, maybe there really are creepy things out there on some of the haunted byways surrounding Cape Girardeau.

SPOOK HOLLOW

Spook Hollow is one such eerie stretch of road with a long history of the unexplained. This low-lying part of Old Orchard Road between Cape Girardeau and the neighboring town of Jackson just off the I-55 loop is haunted by an unnatural white fog that rises up from the countryside on some nights to completely cover the thoroughfare. The epicenter of the vaporous phenomenon appears to be the area between Old McKendree Chapel on the north and Old McKendree Cemetery on the south. Encounters here were first documented by newspaper accounts in the 1880s, and for generations since, travelers have experienced an ashen mist so dense that, at first, horses and, later, automobiles have found it extremely difficult to navigate through. In some versions, however, the vapor is more distinctly shaped. People driving near Old McKendree Cemetery at night have reported seeing a hazy cloud about the size of a man moving through the graves. And while its indistinct features make it difficult to say for certain whether the apparition looks human, they agree that the way the mist moves looks exactly like the locomotion of a man walking at a determined pace.

Some have rationally suggested that atmospheric conditions are responsible, but the apparently random timing of the fog's appearance argues against this theory. Likewise, advances in road surfacing techniques and steady housing development are sometimes offered as logical explanations, yet stories of the ghostly fog not only predate these improvements, but descriptions of its appearance along this winding lane have also remained fairly consistent through the years. Even traditional stories about phantom railroad steam are problematic given the exact location and the fact that the era of intense railroading in the region came well after the earliest known sightings.

One popular story among teenagers is that the more human-shaped mist has something to do with an axe murder that took place in the tree line around the cemetery in the 1980s. This, of course, does not account for the previous one hundred years of Spook Hollow stories handed down over generations. That type of longevity has bred its own ideas about the haunted origins of the haze. There are those who speculate that the heavy fog is breathed out from the very earth, which was imprinted by the suffering of Cherokee Indians who camped in a number of unknown locations throughout Cape Girardeau County in the bleak winter of 1838 and 1839. Thousands of Cherokee died on what history remembers as the Trail of Tears, including dozens in and around the nearby state park, which commemorates the place where the refugees were forced to cross the freezing Mississippi. It could be their sorrow manifests itself as this phantom haze over the ground near the city limits of Jackson, which is named in honor of the president whose Indian removal policy brought them here.

BLOOMFIELD ROAD

Since the antebellum years, Bloomfield Road has wound its way through the heavily forested hills southwest of Cape Girardeau toward Stoddard County. For generations, this highway represented one of only three main overland routes into the Cape, and well before Union and Confederate armies clashed along its length, the town's elite were already building secluded summer homes among the virgin timber. Today, in the era of new subdivisions and a lavish golf course, the houses along Bloomfield Road are considered mostly upscale suburban Cape Girardeau. But there was a time before automobile traffic when the road was well beyond the city limits, and the wealthy retreated to the cool forest shade in order to escape Cape's teaming masses and sweltering summers. For common folks, the exclusiveness of Bloomfield Road gave the lane a forbidding aura, which was significantly reinforced by the huge trees on each side that extended together over the roadway, giving it a dark, tunnel-like feel. More often than not, a thick fog settled over the hollows after dark as well. Those curious enough to travel out

A stretch of Bloomfield Road looking south just beyond old Mount Tabor Park. *Photograph by Joel Rhodes.*

there to gawk at the opulent manor houses with names like Elmwood and Briarwood often did so with a genuine foreboding. Historically, their fear may well have been the origins of the road's haunted folklore. Witnesses beg to differ, however, and they adamantly insist that this stretch of black top is plagued by malevolent forces and must be considered among the most haunted roads along the Mississippi River.

The early nineteenth-century settlers to this high ground above the great wetlands of "swampeast Missouri" were the first Europeans to share stories about meeting a headless traveler on the darkened road. Details about his manner of dress—an Indian brave, Spanish explorer or French trapper—varied depending on whose cabin or around whose hearth the tales unfolded, but in all of them, the unfortunate wanderer was missing his head. So, too, did they question the specter's motivation. Was he a tragic figure searching in vain for his severed skull or a sinister highwayman determined to replace his own by separating a

weary passerby from his? After the Civil War, the decapitated presence walking in the moonlight began menacing Bloomfield Road astride a fiery black steed. And again depending on the present company, this headless horseman with sword in hand wore either Union blue or Confederate gray.

A decade or so after the war, locals also spoke of a ghost lantern bobbing beside Bloomfield Road on certain stormy or foggy nights. According to the legend, two young sisters were returning to their family's stately home from a society dance around midnight when a dense fog bank enveloped the desolate stretch of the road their buggy traveled. With very limited visibility, the horses spooked easily, and while rounding a particularly blind bend, one of the beasts reared unexpectedly. The horse's panic violently upset the carriage, overturning it and tossing the sisters aside like rag dolls. One was gruesomely impaled on the spokes of a broken wheel. Her sibling, bruised and broken from being partially crushed under the buggy, struggled free to wave their lantern urgently back and forth in the hopes of flagging down help. But in the morning light, when another surrey finally happened to find them, both were dead. The first sister, they said, probably died instantly, but judging from the hundreds of muddy tracks, the second sister, it was thought, must have run up and down Bloomfield Road desperately waving the lantern for hours. It rested in her clutched fist where she lay, still lit.

Almost immediately thereafter, whenever a nighttime fog settled over this part of the lane, townspeople in buggies and on horseback reported what they called a "spook" light urgently swinging side to side through the mist. Eventually, horses gave way to automobiles along Bloomfield Road, but even today, sightings of the light persist. More than one late night driver has done a double-take, forced to admit that what they initially thought was just a distant front porch light might actually have been the faint glow of the sister's lantern warning them of a dangerous curve ahead.

The most notorious of the restless spirits haunting Bloomfield Road remains Mad Lucy. Similar to the ghost lantern, the first known stories of Mad Lucy date to the generation after the Civil War, when nervous travelers tried to account for inexplicably spooked horses at certain points along their journey. Some of these mysterious buggy accidents ended with real documented injuries. Victims often blamed the mishaps, not on wild animals or weather, but on the wails and shrieks of a banshee, which they claimed had terrorized their teams. The banshee, locals

feared, was Lucy, an unfortunate wretch well known in these parts and even reported on in some newspapers.

Lucy, it seems, had lived on her family's farmstead beside Bloomfield Road in the years after Missouri statehood. These were grim times in the history of Cape Girardeau, when the community suffered through a period of crippling stagnation and neglect. The downtown itself consisted of fewer than two dozen log cabins, some in ruins, and a handful of other unoccupied and otherwise derelict public buildings. Way out on Bloomfield Road, Lucy lived in the isolation and squalor of many pioneer families who scratched out an existence on the frontier. At some point, the drudgery, loneliness and hopelessness of her bleak world broke Lucy, and she slipped into madness. Those on neighboring farms shuddered to hear her anguished and insane screams echoing along the road and over the black hills at all hours of the night. So unrelenting were her cries, and so upsetting, that many whispered that it must be the result of demonic possession.

For its part, her distraught family took to locking Lucy away in a primitive outbuilding with the other animals, a condition that only enraged her troubled soul and amplified her nightly howling.

Finally, locals could stand no more. They came from the surrounding farms for miles around to see Mad Lucy for themselves and beg her family for some relief. But when they arrived, the farmers discovered the place was completely abandoned and, by the looks of things, had been for quite some time. There was no trace of the family, their belongings, livestock or Lucy. Yet the screaming had never, nor would it apparently ever, cease.

MOUNT TABOR PARK

In the last decades, Mad Lucy's screeching has been joined by yet another ethereal voice calling out on the winds that whistle down Bloomfield Road. Together, their chilling cacophony has rattled even the strongest of nerves for those who have ventured around old Mount Tabor Park. These grounds on Bloomfield Road, about a mile from Cape Girardeau, are now a private residence and no longer accessible

to the public, but bicyclists and runners still claim to have heard an elderly woman's moaning emanating faintly from the site.

So, too, have motorists suffered emotional distress and grave damage to their vehicles while trying to avoid a ghostly lady in white as she gracefully leaves Mount Tabor Park. According to local sources, an adolescent girl was murdered in the park sometime in the 1970s before Mount Tabor closed. The trauma of the event tarnished the area to the point where, for a few years, people shunned the once popular teenage hangout, and the property eventually sold. Not long after, young people cruising Bloomfield Road after midnight reported a slender female in what appeared to be a tattered and muddy white nightgown coming out of the former park. A few described the figure walking slowly down the road toward oncoming traffic. Others insisted she crossed Bloomfield Road, only pausing long enough to glance over her shoulder as they approached. One or two saw the girl in white making her way back across the road to reenter Mount Tabor Park. Once inside, they say her shadowy form simply vanished altogether, but not before the distinct sounds of muffled screams could be heard in the dark forest.

Most residents along Bloomfield Road near Mount Tabor Park may be disbelievers, but there is no arguing that a considerable number of accidents along this route are of the one-car variety. Many of the cars wind up in the ditch, but there are also property owners at a loss to account for why they are perpetually replacing the same sections of damaged fencing. And despite whatever excuses the drivers may offer authorities about why they swerved as they did—bounding deer, scurrying squirrels or hazardous conditions—in private some will confess to having seen the ghost. Standing in their headlights, wisps of hair flowing in the breeze, the expressionless face is always the same with dark, hollow eyes not really seeing their approaching car but rather staring through it down the road.

It's little wonder there are middle-aged Cape Girardeans who deliberately have not driven down Bloomfield Road after dark for over twenty years and, regardless of the inconvenience, swear that they never will again.

CEMETERIES

Tucked away in every corner of Cape Girardeau and its surrounding county are dozens upon dozens of sacred spaces honoring the final resting places of bygone generations. Some are well-manicured, expansive gardens befitting the earthly esteem given to those buried there. Others are not quite so sprawling: solemn little churchyard plots, easily overlooked municipal burial grounds bounded by commercial development and rural family graveyards amid small stands of trees on lonesome farm hills. These peaceful places of interment are hallowed grounds, deeply revered spaces for the bereaved to honor departed friends and family. Genealogists, historians and preservationists are likewise drawn to these sanctuaries for the textured and rich insight into our heritage inscribed on their tombstones. Yet cemeteries are also the physical repository for the material from which many of our ghost stories arise. They offer not only the constant reminder of our own mortality but also the poignant mysteries of death, mourning, lost love, unfulfilled promise, tragedy, loneliness and ultimately decay. Along with haunted houses, graveyards and their eternal inhabitants are ubiquitous in our haunted folklore. These accessible places, at once familiar and unfamiliar, allow the brave of heart into a spooky world of full moons at midnight, mystical conjuring and restive spirits walking the earth.

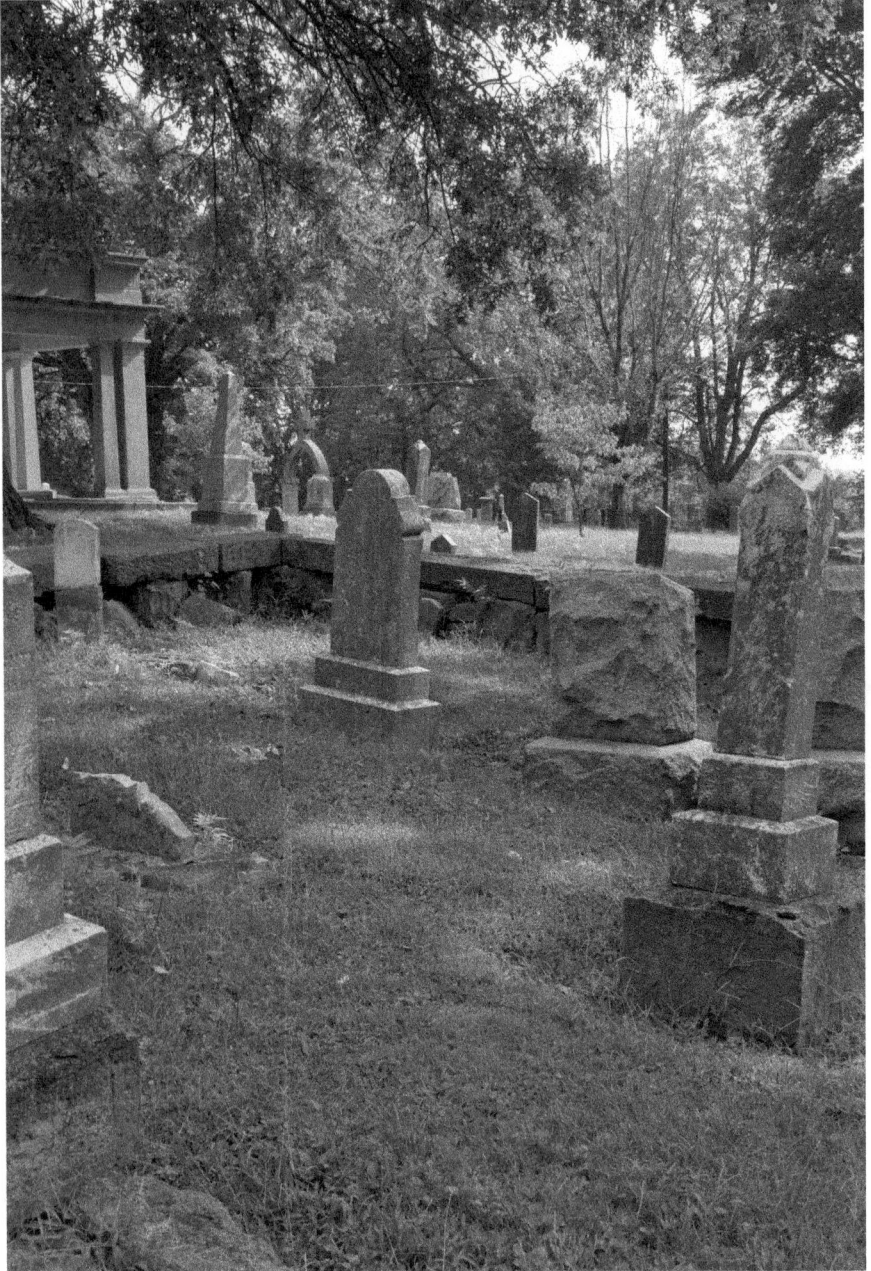

Old Lorimier Cemetery is one of the oldest cemeteries in the state of Missouri and the final resting place of many of Cape Girardeau's founding citizens. *Courtesy Cape Girardeau Convention and Visitors' Bureau.*

Moreover, in our modern culture where scares come cheaply and vicariously, cemeteries remain one of the only surviving places where fear is honest and genuine.

NEW LORIMIER CEMETERY

When townspeople speak of Lorimier Cemetery, they are actually referring to two—Old and New Lorimier—although those distinctions are relative. Both, of course, are named for Louis Lorimier, the man commonly understood to be the founder of Cape Girardeau. But whereas Old Lorimier on North Fountain Street near the Mississippi is over two centuries old, graves in the newer incarnation on Caruthers Avenue date back to *only* the early 1870s. This New Lorimier, which opened essentially because the much smaller and landlocked Old Lorimier could not keep pace with demand, now contains nearly nine thousand graves over its roughly eleven acres, which are divided into seven sections or blocks. The vast majority of the orderly graves are marked by single headstones or monuments, though a distinctive mausoleum from the second decade of the twentieth century on the north end contains over two hundred crypts.

Over the years, those venturing through the grounds of New Lorimier have encountered a number of specters among the graves and other ghostly figures wandering the various blocks. By far the most persistent legend involves glowing green eyes staring out from behind certain monuments. Neighborhood schoolchildren have sworn over the years that they are the most recent witnesses to the nocturnal phenomenon, which has never been satisfactorily explained by passing headlights or reflections off polished headstones.

In the last several years, researchers from the Paranormal Task Force have conducted a series of nighttime investigations of New Lorimier, usually targeting those portions of the cemetery traditionally considered the most active. The team has based their investigations on the consistent recollections of former caretakers who reported hearing disembodied voices and entering remarkably distinct cold spots, not to mention feeling the "touch" of phantom hands. In these discreet areas,

New Lorimier Cemetery on Caruthers Avenue. Paranormal investigators believe that what looks like a stick figure seated by the side of the road is the residual energy given off by a spirit as it attempts to manifest. *Courtesy Paranormal Task Force, Inc.*

they have, indeed, recorded places where their thermometers dipped considerably lower than the ambient temperature. One mystifying spot registered at a chilling twenty-four degrees Fahrenheit when the surrounding outdoor readings were a comfortable fifty degrees. What is more, this cold spot moved in a decidedly deliberate manner, maneuvering around their perimeter as if, they surmised, it was a timid child genuinely wishing to get their attention but ultimately too shy to follow through.

Several traveling, and equally arcane, EMF spikes have strengthened the team's belief that it was on to a significant haunting. In the interest of full disclosure, I participated in an amateur ghost hunting exercise near this very area of New Lorimier on a different occasion. At the time, my research on an unrelated biography of railroad pioneer Louis Houck was well underway, and as the team involved that night entered a private quarter of the cemetery, our EMF meters began dancing with

pronounced levels. Flashlights quickly scanned out across the stones to establish the exact location, and eerily the markers all read exactly the same name: Juden. Perhaps it was mere coincidence that the group stood in the middle of the Judens' family plot, a prominent clan who are by marriage intimately intertwined in the Houck family tree. Or maybe the old railroader's kinfolk were greeting the historian who was finally telling some of their most treasured family stories.

The aforementioned paranormal group also recorded two intriguing electronic voice phenomena (EVPs) during its investigations. When these recordings are played at different speeds, the disembodied voices sound uncannily like a female or child's voice, in one case trying to accompany the investigator's singing. Moreover, the team captured one of the most remarkable photographs ever taken in a Cape Girardeau cemetery. In the digital image, what appears to be the pale white silhouette of a human shape can be seen sitting in the foreground on the grass near the doorway of a crypt with its ghostly legs resting on the road, a rare and frightening sight to be sure, but what is more, when further enhanced, a second, more disquieting figure comes into focus. This shadowy form, unmistakably human in nature, appears to be approaching the road by the entrance of the same tomb, its gray arms held close to its body.

OLD LORIMIER CEMETERY

Directly east of New Lorimier, toward the river, the older and more historic Lorimier Cemetery sits grandly atop the sloping hillside, overlooking the Mississippi amid one of this part of town's remaining wooded areas. This peaceful, five-acre tract at 500 North Fountain Street, nestled just a couple of blocks north of Old Town Cape Girardeau, was the town's first graveyard and is, in fact, one of the oldest cemeteries in the state of Missouri. Set aside by its namesake, Louis Lorimier, in 1808, the earliest people buried here were born in the Revolutionary War era, and for over two centuries, these grounds— which are listed on the National Register of Historic Places—have remained the final resting place of Cape Girardeau's own founding fathers. Indeed, most of those interred are from the late Victorian

period, when Cape Girardeau underwent its most prolific years of development. The cemetery is no longer used for burials today.

In sections once designated for Catholics, Protestants and various ethnic groups, the branches of gnarled and aged trees shade distinguished family plots while their roots push up incomplete rows of broken and weathered headstones. Of the estimated 6,500 graves, only somewhere near 1,400 are actually marked. Some of these monuments are spectacular examples of nineteenth-century funerary iconography, often demarcated by ornate wrought-iron fencing. Others are rather modest. However, most burials are simply lost to history. It is believed that perhaps as many as 1,200 Civil War soldiers from the Union army were laid to rest here, most having died of smallpox in the temporary hospital nearby. A mass grave on the southeastern corner is thought to hold the remains of crew members from a riverboat disaster, and segregated next to it on the eastern slope are probably the unmarked remains of the city's African American population.

Understandably, Old Lorimier Cemetery is often regarded as Cape Girardeau's most haunted place, a shadowy and well-deserved reputation dating back to its very inception. Louis Lorimier originally donated the site, which in 1808 lay well outside of town, for the purposes of burying his recently deceased wife. A French-Canadian, Lorimier had arrived in Girardot's "cape" in 1796, after being run out of Ohio for organizing and supplying Delaware and Shawnee Indian raids against the Americans during the Revolutionary War. In these years, just prior to the Louisiana Purchase, the territory was still under Spanish control, and the crown appointed Lorimier commandant of the Cape Girardeau district, a position that made him responsible for all record keeping, law enforcement, military matters and Indian affairs.

By all accounts a striking figure known for a flowing mane of black hair he characteristically braided into his belt, Lorimier brought many of his Delaware and Shawnee allies—and a healthy dislike for Americans—with him from Ohio, including his Shawnee wife, Charlotte. She passed away just five years after the couple grudgingly received the explorer Meriwether Lewis and his intrepid Corps of Discovery at their "Red House," near the spot now occupied by Old St. Vincent's Church. Although the frontiersman could neither read nor write, Lorimier made it known that he chose this particular site to bury his beloved Charlotte because he wanted her returned to her people on the hilltop. In that tradition, he accompanied her earthly body in

a canoe upstream and then carried it up the hill from the Mississippi. Though Charlotte Lorimier's was documented by whites as the first burial in the new cemetery, her devoted husband's actions would seem to indicate otherwise. According to Dr. Frank Nickell, Charlotte's death "supports the idea that Old Lorimier Cemetery may have been used as a Native American burial ground long before there were Europeans here." As a matter of fact, even in the earliest years, just after Louis Lorimier joined her there in death in 1812, gravediggers were already disturbing much older funeral sites and uncovering human bones.

Upsetting this hallowed Native American site may have stirred the spirits in the nineteenth century, but more recent construction projects have troubled them even further. Access to the cemetery has been completely reversed. The current main cemetery gate on Fountain Street actually marks what was historically the rear of Old Lorimier (the primary entrance used to open toward the river). In addition to this major reorientation, the current fence line does not actually encompass the entirety of the area once used for burials. No one really knows the exact original parameters of the cemetery, which means many of the unmarked graves may still lie well beyond its modern borders. When Fountain Street was built, many graves had to be exhumed and moved. So, too, did construction crews working on nearby apartments unearth both intact coffins and scattered bones. Not surprisingly, this neighborhood immediately surrounding Old Lorimier has witnessed unnatural occurrences for over one hundred years.

Locals say that Old Lorimier is the most lively and active just before a storm, when the winds are first starting to rustle the trees and the cloudy skies bristle with static energy. Perhaps it is the lightning's promise of electronic charges or the raw power of the wind's gusts that enables the dormant spirits to manifest. Or maybe it is nothing more than elongated shadows in the waning light playing tricks on a spooked passerby. Whatever the reason, it is on these darkened days that residents have most frequently seen the outlines of ethereal riverboat men roaming the southeastern corner or being drawn through the woods toward the Mississippi. Witnesses also tell of a ghostly child wandering through the headstones and hiding behind the trees. She is usually dressed in a small white gown that wafts in the rising breezes as she glides between rows of headstones. Sometimes the little one is accompanied by a pale and forlorn woman who might on one evening appear to be searching for her diminutive companion and on another holding her by the hand.

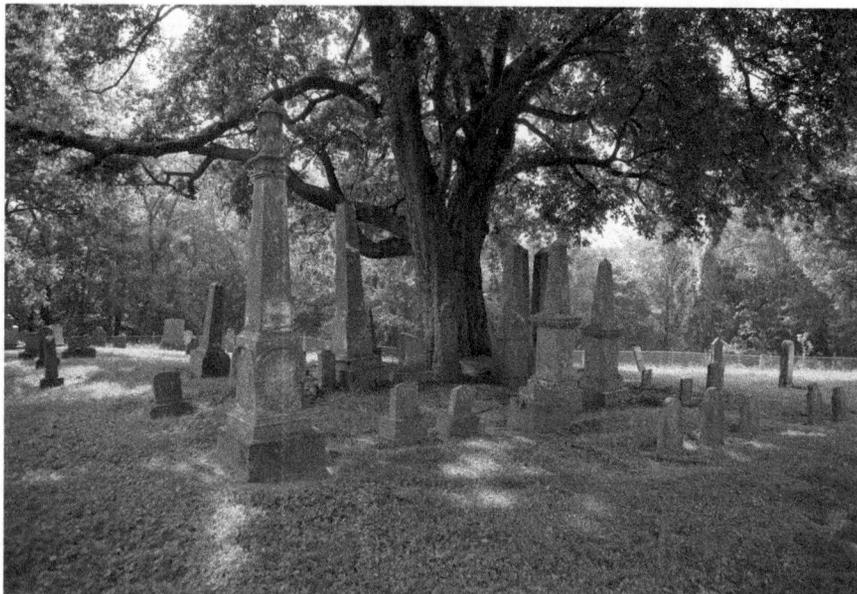

Old Lorimier Cemetery. *Courtesy Cape Girardeau Convention and Visitors' Bureau.*

In the last few years, a resident living in the apartments that back up to the cemetery on the north was unnerved by the sight of this floating lady making her way through the moonlit graveyard toward his very window. As she moved steadily closer, he could distinguish more detail in her ghostly features until she paused just inches from the glass, gazing at him eye to eye as he stood motionless in his second-floor bedroom.

The most well-known and enduring entity in Old Lorimier is the famed "Tapping Ghost." Considering that the cemetery was not entirely fenced until just a couple of decades ago, people walking through the area routinely took shortcuts over the grounds at all times of the day and night. Those living in the blocks to the north followed well-worn cemetery paths on their way to the downtown district, which, at the time, was where all the businesses were located. Dr. Nickell explains that over the years,

> *many people indicated, and have told persistent stories, that as they were walking through the cemetery someone would tap them on the shoulder. They would turn to the right or to the left and no one* [would

be] *there. And then they would look and think, "Something must have fallen on my shoulder. It must have been a hickory nut." And they would walk a little further, and then two taps, or three taps. And then they would be frightened and dash off to downtown, wondering, "Who is this? What is this?" And so there were many people who would report to newsmen and it would be placed in the local newspaper that there was a "tapping ghost" in Old Lorimier.*

The first such instance of this experience comes from the January 26, 1938 edition of the *Southeast Missourian.* Under the headline "7 Mysterious Taps Alarm Man on Walk Through Cemetery," the newspaper chronicled the story of an African American man who encountered "seven mysterious ghost-like taps on his arm as he walked through historic Old Lorimier Cemetery in the cold gray dawn of a recent morning." The man, a caretaker who lived on Mill Street near the cemetery, reported that "for months [he had] used a path through the cemetery in going to his work in a Broadway building," finding it more "convenient to walk through the cemetery because of the time and distance saved."

However, he explained that "the other morning, just before dawn, as he walked across the cemetery toward the south from near the northeast corner, he felt seven distinct tappings on his right arm, all between the wrist and elbow. He could see or hear nothing, and each tap felt about like his arm was being struck pretty briskly with an empty glove." The article goes on to clarify that

> *shortly after he passed the first graves at the north side of the cemetery, the man related he felt a tap on his wrist. Glancing around quickly he saw only nearby tombstones, nothing else, so he thought little of the incident.*
>
> *He walked ahead at the same gait, he said, when he felt another rap on the same part of his arm. Again he looked all around, but could see nothing in the early morning haze except jutting tombstones.*
>
> *Three other taps followed one by one until finally, near the giant elm at the Don Louis Lorimier tomb, he felt another gentle blow, the sixth one. He wheeled about to see if anything was around, and as he did so felt the seventh and last mysterious tap.*
>
> *He then walked, the man said, from the cemetery. This morning he said he used the same path through the graveyard again, but had no unusual experience.*

This account apparently drew enough public attention that two investigative reporters from the *Southeast Missourian* staked out the cemetery that same morning hoping to hold the tapping ghost up to journalistic scrutiny. Under the next day's enticing headline "Reporters Seek Tryst with 'Tapper'—Pay Early Morning Visit to Cemetery to Keep Appointment," the skeptical newsmen told their readers how they had braved the frigid north winds in the predawn hours with only "chattering teeth and flapping overcoats." Parking their car on Fountain Street, they crept through the west side of the still dark graveyard to set up their surveillance by the crypt of Louis Lorimier himself. But, alas, after several fruitless hours huddled together, with only the gentle winds and periodic barks from curious dogs to draw their attention, they ultimately declared their search a bust. While seeing "nothing ghostlike" they did, however, observe that the cemetery's normal foot traffic was conspicuously absent on this morning. Those making their way to work were bypassing the cemetery altogether.

Not all experiences with the ghosts at Old Lorimier involve playful taps on the shoulder. There have been a number of odd accounts, primarily from women who have been walking through the cemetery, that involve someone or something tugging or stroking walkers' hair from the back. Dr. Nickell recalls a recent tour group from Washington, Missouri, that was visiting Cape Girardeau with the sole intention of exploring the town's haunted places. He, of course, brought them to Old Lorimier Cemetery, where they proceeded to spend most of a very creepy night. At one point, a young woman standing alone near the family plot of Louis Houck recoiled from a forceful yank on her hair. Initially, "she assumed it was a good friend of hers," Nickell says. "But she turned and there wasn't anyone there, and she thought, 'Well that's strange,' and discounted it. She turned back, and then there came two tugs and she became frightened and dashed off to join the crowd for support."

A mother-and-daughter team of amateur ghost hunters spent several nights in Old Lorimier a few years back and likewise came away with similar sensations of something touching or playing with their hair. Equipped with cameras and a tape recorder, the two took a series of pictures around the most notorious trees and headstones. These photos captured a number of floating orbs of various sizes and more than one strange image suspended between two monuments that they were simply at a loss to adequately explain. They also experimented with

Dr. Frank Nickell conducting an evening walking tour of Old Lorimier Cemetery. Notice the large orb resting near the top of the headstone immediately behind him. *Photograph by Joel Rhodes.*

interactive questioning that yielded, over the hours of tape, a number of seemingly random words from what sound like low, guttural voices.

But four segments in particular contain absolutely chilly conversations between the women and some of those haunting Old Lorimier. After inquiring about the identity of one spirit willing to make contact, they recorded what sounds to be a human voice explaining that he is the son of Jacob Miller, or maybe Milner. The entity then labors intently and repeats over and over the words "water" and "river." His urgency and insistence convinced the two that Jacob's son may have been a drowning victim from a steamboat wreck and was pleading with them to drag the Mississippi for his missing body. When the daughter followed up with a query about whether others might want to come forward to be heard, the tape recorder plays back, "Yes we all…"

On a subsequent visit, they recorded another disembodied voice curiously asking, "Why…come back?" And toward the end of that late night stay, the daughter—whom they believe the spirits preferred—felt that storied touch of something on the back of her head.

Still another adventurous group may have run into these same specters during a moonless Halloween night in Old Lorimier. Eight friends were enjoying the usual holiday traditions of scary movies and ghost stories when they spontaneously agreed to up the ante with a

midnight séance in Cape's most haunted cemetery. Because they lived just off campus, a few blocks from the graveyard, they decided to walk the distance in the hopes that the stroll would heighten the spooky experience, especially considering that the route they deliberately chose for coming and going went directly by the Sherwood-Minton House, another notable haunted location. Finding the Fountain Street gates closed to ward off just this type of revelry, they eventually gained access through the southern entrance and proceeded into the heart of the cemetery, passing the white concrete caretaker's shed on the gravel path. With anxious whispers—and the hair on the backs of their necks admittedly standing on end since they crossed the threshold—the group formed a circle, sitting cross-legged together and holding hands under a knotted oak. There, among some of the oldest graves to be found, a Wiccan among them led the séance with an incantation and responsive chant. They immediately noticed that every time he repeated the same specific phrase in the summons, the security floodlight nearest them on a telephone pole lost power momentarily, fading considerably before regaining strength. Several in the circle began to catch glimpses of movement in their peripheral vision to the point that they openly questioned whether other would-be thrill seekers might be playing a prank on them.

At this point, adrenaline was running high, and their breathing became increasingly heavy and palms sweaty. Some were already freaking out. Within the circle, a girl struggling to hold her concentration and composure became increasingly aware of what felt like bugs crawling over her neck and up through her hair. Yet when she brushed a shaking hand through her tresses, there were no insects at all. Minutes later, as the séance recitations continued, the crawling sensation moved to her right temple, where it grew into a rhythmic tapping. Then, she sensed gentle touches along her arms as if someone's hands were lightly holding her from behind. That was enough for her, and she abruptly stood up, unceremoniously declaring her participation in the ritual over. As she did, a gaunt, white figure caught her eye.

For the next several minutes, she pleaded with the group to go home before things got out of hand, all the while rationalizing in her mind that the figure she glimpsed over her shoulder must have been part of the white shed they passed initially on the way to this spot. Only after the Wiccan agreed that he also sensed too much activity around them did they finally leave the cemetery, following the gravel path whence

they came. However, in a fitting conclusion to their brush with the unknown, on her way out, the young lady realized that the shed was not anywhere near where she originally thought. In fact, from where they conducted the séance, there was no possible way to see it.

Aside from the tapping ghost and its apparently kindred spirits, Old Lorimier keeps still other secrets as well. One of the most longstanding legends about the cemetery involves a tunnel that purportedly connects the burial grounds to another of Cape Girardeau's most recognizable haunts, the Sherwood-Minton House, located just a block away. From what we know, the Sherwood-Minton House served the occupying Union army as a smallpox hospital during the Civil War. Given that the disease could easily decimate a substantial military force without an enemy shot ever being fired, this was not an inconsequential service provided by the antebellum home. Considering, also, that Cape Girardeau was a community peopled with a significant number of Southern sympathizers, it behooved Northern commanders, from a strategic standpoint, to conceal the extent of a disease like smallpox, especially the death toll, in the ranks. For this reason, it is believed soldiers constructed an underground tunnel from the Sherwood-Minton hospital to Old Lorimier Cemetery in order to clandestinely move their dead comrades without revealing their thinning ranks to Confederate spies or undermining the morale of loyal townspeople. As an added level of security, stories have it that these grim processions took place under the cover of night.

Although there is no historical record or archaeological evidence of the fabled tunnel, with perhaps over one thousand Union troops buried in unmarked graves here, there is a certain plausibility to it. According to Frank Nickell, since the Civil War, Cape Girardeau has had these "stories about processions of soldiers bringing dead bodies to be buried in Old Lorimier in the middle of the night without any record. That gives rise to all of the stories about the ghosts of Old Lorimier and the connection to the Sherwood-Minton House, which is supposedly haunted by the ghosts of those soldiers who died there in that hospital." Indeed, for generations the two places, within eyesight of each other, have been closely linked in the paranormal imagination of the town. People who have seen strange lights swinging back and forth in the dark cemetery immediately connect it to the Civil War burials and assume these are ghostly military grave diggers, finding their way back to the Sherwood-Minton House by phantom lantern light. And curiously,

some who have ventured into the Sherwood-Minton basement insist that they experienced the same weird tappings commonly associated with Old Lorimier. Is this a different tapping ghost, or maybe the same entity still moving through the tunnel each night?

HAUNTED HOUSES

From roughly 1906 until the opening years of the Great Depression in 1931, Cape Girardeau underwent the most dramatic period of growth, expansion and development in the city's long history. The population surged from 4,815 in 1900, to 8,475 in 1910 and to 10,252 by 1920. After the rebuilding of Academic Hall silenced talk about moving the normal school away from town, the student population at Southeast Missouri State Teachers' College, as it was officially designated in 1919, increased nearly eight fold. The city limits also stretched with the annexation of the Red Star neighborhood to the north and Smelterville to the south. Toward the west, Cape inched beyond Frederick Street, further closing the gap between the town and university. Just as these boom years transformed the business district of Old Town Cape, many of the construction projects between 1906 and 1931 gave Cape Girardeau much of its modern residential architecture as well. A rich collection of popular styles and forms influenced this construction boom, ranging from magnificent Italianate homes near downtown to Colonial Revival and Queen Anne in the more affluent districts. The middle- and working-class neighborhoods that proliferated during this era—such as the Sunset neighborhood and areas to the north around today's Southeast Missouri Hospital and Capaha Park—are

likewise populated with American Foursquare, Craftsman, Bungalow, Tudor Revival and various vernacular Folk Victorian house forms.

With plenty of homes and history here worth haunting, Cape Girardeau's older blocks are replete with countless tales of ghostly activity. In truth, there are far too many for one brief volume, or even several lengthier ones, to cover with any detail, and so this chapter dwells on a sampling of just four: one obscure and three classic Cape Girardeau haunted houses.

A HOUSE ON MISSOURI STREET

At the dawn of the twentieth century, 1900 to be exact, the Southeast Missouri District Fair moved to a forty-acre parcel of land immediately west of the university campus. The newly formed Cape Girardeau County Fair and Park Association christened the new location Fair Ground Park and set about building a grandstand, pavilion—for displaying crafts, music, baked goods and flowers—sulky track, baseball diamond, lagoon and clubhouse overlooking the water. The city eventually purchased the park from the association in 1915 and leased it to the Chamber of Commerce to continue the perennial "Old Cape Fair" in this central spot until it moved to its current site in Arena Park just prior to World War II. Today, those old fairgrounds bordered by Perry Avenue, Broadway and West End Boulevard are Capaha Park. This pastoral commons, now the oldest of the city's parks, still features a wholesome variety of entertainment, including baseball fields, playgrounds, band shelter, rose garden and scenic fishing pond.

The largely middle-class neighborhoods surrounding Capaha Park are likewise family oriented. Many homes date from those boom years, nestled close together and mostly very well cared for. However, a couple of blocks north of the park on Missouri Street, within easy walking distance for children, an unassuming little residence in the minimal-traditional architectural style belies the peaceful appearance of this part of town.

A former owner, who wishes to remain anonymous, spent several years living in this Missouri Street house with her young family

The neighborhood around Missouri Street just blocks north of Capaha Park. *Photograph by Joel Rhodes.*

and, as she came to learn, at least two inhospitable entities. Almost from the day they moved in, the new mother could never feel quite comfortable, or at home, in her surroundings. Being her first home purchase, this should have been a proud and exciting time for setting up housekeeping, but a vague uneasiness gnawed at her as she unpacked that never really lifted thereafter. Even before her children were born, common items would go missing and turn up in curious places. Car keys that had disappeared days before were discovered in the refrigerator. The hair dryer from the bathroom made its way to the living room couch. And an identity badge from work was eventually found in a coat pocket not worn for months.

These disquieting feelings became more acute when she began to sense the presence of an aged man eyeing her menacingly wherever she went through the house. He watched as she went about her daily household chores. Regardless of whether it was a bedroom, the living room or the kitchen, when she entered a new space his stern gaze

would soon follow. While cooking or washing dishes at the kitchen sink after dinner, she caught fearful glimpses of his reflection studying her through the window. The relentless old gentleman even kept her from relaxing in front of the television. Some nights his ghostly face—always blurred and indistinct—leered at her through the pictures onscreen. On others, in the dark corners of her living room, the flicking lights of the screen would momentarily illuminate his shadowy form, keeping her nerves constantly on edge.

Neither did sleep afford an escape from his ethereal notice. In a recurring dream, he emerged each night from his "home" in the large unfinished attic area off the master bedroom. He moved swiftly to her bedside and remained there, glaring down as she slept, until an awareness of his presence jarred her awake. Invariably, when that moment came, even in a disoriented state, she was fully cognizant that if she opened her eyes, he would really be there, watching and waiting. Often, she lay terrified and motionless with eyes tightly shut for hours until he returned from where he came in the attic.

One afternoon, while she was folding laundry in that bedroom, he came back earlier than expected. Her large German Sheppard noticed the shadow first, but the warning growls came at almost the exact moment the door slammed forcefully shut. As she attempted to reopen it, the antique knob on her side of the door mysteriously fell off in her hands. That knob had been turned hundreds of times since they had moved in and never once appeared even slightly tricky. But now, even as she vainly tried to move the bolt with her fingers, it would not budge. She was trapped. And with her husband at work and children away for the day, that is where she stayed, alone with the dog for nearly five hours. When help arrived at the end of the day, they managed to move the locking mechanism effortlessly and could find no earthly reason why she could not have done the same at any time.

Not long after, she acquired a powerful and very real feeling that his intentions were to show her that there were parts of the house that did not "belong" to the family. Rather, these upstairs rooms—the attic and adjacent cedar closet—were, like the bedroom, to some extent still his.

For whatever reasons, the spirit, which she never clearly saw and could only describe as "a creepy old man," paid no heed to her two very small children or husband. This left the woman to deal with the haunting largely in silence. She avoided the cedar closet and, even during the holiday season, still found an excuse for not entering the

attic to retrieve the Christmas decorations. Most nights, she slept in the children's bedroom, where her dreams remained her own. But eventually, the kids began to sense her fear, and they too started to feel out of place in their own home, never venturing into some rooms alone and avoiding certain areas altogether. One of those forbidding spaces was the unfinished portion of the basement, and a terrifying encounter there involving her preschool daughter finally brought the situation to a head and hastened their departure from Missouri Street.

It had always puzzled the mother that whoever haunted the house would appear to her as a man. She knew for a fact, before moving in, that the previous owner, an elderly lady, had actually died in the house. Yet only this unknown man insisted on staying. Then one day, while her two-year-old played in the basement, the little girl's shrill screams brought the frantic mother down the stairs in several bounds. The child breathlessly explained in her somewhat incomplete English that her ball had rolled innocently out of the finished area of the basement into a faintly lit portion used as a laundry room and additional storage. When toddling after it she came face to face with a severe-looking, aged lady standing above her in the darkness. Trembling and pale, she hugged her mother's neck tightly and between sobs clearly articulated a complete and chilling sentence, "That old lady told me to get out."

Now faced with unyielding and harsh spirits "living" in the attic and basement, the young family heeded the crone's warning and bypassed the cellar in their daily routines. Within months, they were chased not only from the underground laundry room but from their home on Missouri Street completely, surrendering the house to its previous ghostly owners.

ROSE BED INN BED-AND-BREAKFAST

The widow's walk atop the Rose Bed Inn offers a magnificent vantage point from which to watch the mighty Mississippi River rolling along just blocks away. From this rooftop perch above the elegant Queen Anne, you can also observe the Southeast Missouri State University River Campus at the base of the equally impressive Bill Emerson Memorial

The Rose Bed Inn Bed-and-Breakfast is believed to be home to a host of wayward spirits. *Photograph by Jeanie Rhodes.*

Bridge. Immediately below you, elaborate and well-manicured gardens, accentuated by fountains and fishponds, complement the meticulously restored Victorian mansion. In truth, the view is only part of the charming bed-and-breakfast's ambiance, which has transformed this block of South Sprigg Street into a genteel sanctuary known for fine dining, hospitality *and* an absolutely scandalous haunted past.

When James Coley and Eldon Nattier purchased the property in 1995, the decrepit house, inauspiciously nearing its 100th year, had been placed on Cape Girardeau's condemnation list and was literally days from imminent demolition. The partners were of a mind to return the once-proud home to its former glory and operate it as an upscale bed-and-breakfast in this older part of town. Both were well versed in the ways of historic preservation and doggedly researched the home's colorful heritage to guide their renovations. They found that this was the Schrader house, built between 1908 and 1910 by William and

Ella Schrader. Not surprisingly, given the house's proximity to the old Haarig district, the Schraders were German. This traditional ethnic enclave around Good Hope and Sprigg Streets had developed alongside Cape Girardeau's riverfront downtown in the nineteenth century as a more easily accessible commercial, social and residential hub for the town's sizeable German population. Turns out, William Schrader, an immigrant, was a highly skilled brick contractor in the Haarig who never learned to speak or write English well. A bit more assimilated and progressive, his wife, Ella, translated for him and actually appears to have conducted much of their business, including signing her name to the deed. It is thought that the Schraders built this brick masterpiece as a lasting testament to William's talents as much as for a family home.

Coley and Nattier knew many of the stories associated with their home—such as William's quirky insistence on carrying water inside from a cistern to fill the bathtubs and sinks despite always having indoor plumbing—but it was their real estate agent who finally introduced them to the one remaining character they had not heard of: Alex. Even as the house stood vacant and largely dysfunctional, their agent asked if they had had the pleasure of meeting the boarder who lived there. Puzzled, the new owners admitted they had not, to which she teasingly assured them that they soon would. Sure enough, within no time, James and Eldon came to understand they were not alone in the Rose Bed Inn. Tools and keys disappeared only to be found in highly unlikely places, and light fixtures seemed to operate on their own schedules. Every evening the innkeepers made sure to leave a chandelier in the downstairs parlor on to accentuate the new décor from the street, but every morning, without fail, the knob would be turned all the way to the off position. Indeed, Alex appeared to be trying to make their acquaintance, so the genial hosts thought it only hospitable to get to know him as well.

Interestingly, in scouring the historical record and folklore for an "Alex" in the house's past, Coley and Nattier discovered that when Ella Schrader passed away in the 1940s, the elderly William and his spinster daughter, Myrtle, could no longer maintain such a large home, so they moved to a smaller residence and put the aging Queen Anne up for sale. With few prospective buyers, the Schraders were eventually approached by an ambitious young man named Alex with an interesting proposition. Alex found himself in a bit of a marital conundrum. He was engaged to a young woman from a relatively

prominent Cape Girardeau family, which was, in truth, several rungs above him on the social ladder. He dreamed of buying the big beautiful house and, not unlike Coley and Nattier, restoring its splendor. In this way, he hoped to demonstrate his worthiness in the eyes of his prospective in-laws by providing his new bride with a mansion fitting for her class. The problem for Alex, however, was money. He did not presently have the wherewithal to buy the house or even come up with a proper down payment. The financial resources necessary to purchase and refurbish such a grand place could only come from his wife's family after the marriage. In the end, Miss Myrtle Schrader agreed to let Alex live in the house for a modest rent while beginning the needed improvements in anticipation for his wedding day and the eventual sale.

Yet it turned out that money and the drive to be good enough for his bride's family might have been the least of Alex's worries. In an era of little understanding or social tolerance of such matters, Alex, quite frankly, was gay. Leading a clandestine double-life, Alex would show his fiancée the various projects he had accomplished on their new home by day, but after hours, he would sit patiently in the darkened front parlor smoking a cigar and waiting for his lover to walk up from the south end of the street. This is, coincidently, the same room where Coley and Nattier's chandelier mysteriously turns off every night.

Of course, the fiancée and lover eventually found out about each other, and in a volatile and appropriately dramatic scene, they confronted Alex in the house. All parties in the love triangle were understandably devastated, and for days thereafter, Alex withdrew to the confines of 611 South Sprigg Street to mourn the failed romances. No one saw him for days until, as Coley tells the story,

> eventually, the neighbors complained of a stench. Someone came and checked the house. Didn't find him. The stench got worse. And the stench led them to the attic. Where people had just gone up to the attic stairs and didn't see anybody up in the attic, they didn't check all of the different parts of the attic. Because once the stench got bad enough, the stench led them around to the other corner of the attic that was not visible from the attic stairs. And that's where they found Alex hanging by the neck.

"Which is where I have my office," Nattier will add.

A view of Alex's beloved parlor, which is now a dining room, from the magnificent staircase in the Rose Bed Inn. *Photograph by Joel Rhodes.*

Despite these gruesome origins, Alex has become a constant fixture at the Rose Bed Inn Bed-and-Breakfast since it opened over ten years ago, and a not altogether unwelcomed one at that. Visitors seem to be equal parts unnerved and delighted by the unexplainable antics of this *other* guest with whom they are sharing accommodations. It is not uncommon to find areas—in one of the main parlors or the grand staircase—where it feels notably colder than the surrounding temperature. Personal objects have been known to move about the rooms, and more than once, lodgers have played a kind of game with Alex, repeatedly getting out of bed to close doors that just keep opening minutes later. Some have felt his gentle hand on their shoulder during dinner or what feels like him brushing up beside them in the narrow back hall. A select few, seeking repose on quiet evenings in the dimly lit parlor, admit to actually hearing his disembodied voice.

Alex is especially prone to manifesting for people who share his name. My son watched in nervous wonder at a dinner there one night

as silverware and other table service utensils gently glided over the soft linen table cloth on their own, periodically rearranging themselves in different patterns. By the time the meal was completed, at least a dozen dinner guests had witnessed the supernatural show. Perhaps in this instance, Alex was just entertaining a child, but there have also been evenings when Alex seems to have taken a disliking to guests and actively made it awkward for them to eat by moving their plates at inopportune times or spilling drinks for maximum embarrassment. Coley and Nattier have come to suspect that this more impolite behavior from their resident spirit is protective in nature and directed toward those Alex thinks may have wronged the owners in some way.

Maybe that reflects the increasingly comfortable relationship and mutual understanding Coley and Nattier have developed with Alex over the years. When some guests have commented about encountering a hired security guard patrolling the inn's parking lots after dark, Nattier politely explains that the person is, in fact, Alex, the ghost watching over the cars and buildings as a self-appointed night watchman. Alex also seems to have respectfully tempered his affinity for fine cigars. One of the spirit's calling cards has been cigar smoke, and many guests have had their first experience with him by smelling this pungent odor, particularly in the front parlor where he kept vigil. Still, the innkeepers believe they have now reached an understanding. "Ever since we've opened this business, we've never allowed smoking in this house," Coley explains. But he says, "Every once in a while, we'll come in the house and [there's still that] unmistakable aroma of a cigar." The difference is, according to the owner, "now I know I can just come in the house, and when I smell a cigar, I can say, 'Okay Alex, put it out!' and immediately the smell is gone."

There are still fleeting moments when the glimpse of a shadow or something in their peripheral vision startles them. And, in fairness, they have their squabbles from time to time. Alex, for instance, will sometimes put centerpieces precariously close to the edge of tables. On a recent Sunday morning, Coley and Nattier left some guests to check themselves out while the two were in church. This routinely requires locking the doors of the inn from the outside and simply leaving the keys in an exterior drop box. Yet this time, when they returned, the guests were gone and the door securely locked, but the drop box remained empty. Knowing it to be impossible for guests to lock the front door behind them without keys, Nattier called to gently request

that they be returned. The visitors were sure, however, that they had left the keys in the box as instructed. Nattier assumed the guests were mistaken and told Coley that within a few days they would discover the misplaced keys in a coat pocket and sheepishly mail them back to the Rose Bed Inn. However, when they came downstairs the next morning, there were the missing keys lying in plain view on the marble table in the entry hall. In his mischievous way, the rascal must have kept them overnight to remind Coley and Nattier of his presence and ability to stir things up when he pleases.

But these incidents aside, for the most part Nattier says they have found Alex to be a reasonable ghost. "We've gotten a little more compatible, the three of us, in the last ten years," he explains. "The three of us are getting along a little bit better. He makes a little less noise and we make a little less noise toward him. So we're all learning to coexist a little bit better."

"We speak to him just like we speak to you. Especially if we are alone in the house and the other one is gone, and we hear something or see a shadow, or something, we just acknowledge him and go on. That just seems to be the best thing to do, is just acknowledge him. He wants acknowledgement, obviously."

Their theory on what makes this relatively peaceful cohabitation possible is twofold. First, Coley and Nattier believe Alex is genuinely pleased to have them there because they have finally completed his dream of restoring the home. Second, Alex considers them kindred spirits of sorts, proud of the lifestyle Coley and Nattier are able to live as a gay couple. In Alex's time, such an open relationship would have been unthinkable, and as with their preservation efforts, he is satisfied by this progress as well.

As well documented as Alex has become by both owners and guests, he may be only one of several high-profile spirits that haunt the Rose Bed Inn and its surrounding grounds. The precocious and reclusive Mia silently remains in Coley and Nattier's top-floor living quarters and appears to mostly torment the resident population of cats. A little girl is thought to sometimes play on the main level while departed loved ones were once encountered ascending the main staircase. Over the years, Coley and Nattier have converted the remaining houses on the block into accompanying themed bed-and-breakfasts, and these, too, may attract the supernatural. In addition to investigating the main property, the Paranormal Task Force studied the nearby Gypsy Rose

house during a two-night visit in 2007. Their stay could be considered fruitful. In the Carnival Rose Room, a moving cold spot of nearly ten degrees cooler than the surrounding temperature accompanied a smell they described as musky male cologne. Lights in the Desert Rose Room turned on and off, and at one point, the curtains were slightly drawn back by an ethereal figure. Disembodied voices and footsteps of unknown origins were recorded in the halls, and the team also thought they heard a young girl's soft singing coming from that same empty, and locked, Desert Rose suite.

In the opinion of these researchers, there is more than adequate paranormal activity here to constitute an actual haunting. And that was before they witnessed the ghostly night watchman making his rounds among the shadows in the rear courtyard.

THE GLENN HOUSE

Just south of downtown, at 325 South Spanish Street, on a bluff overlooking the Mississippi, the majestic Glenn House today is open to the public as a Victorian house museum. Completed in 1883 as the private residence of David Glenn, the two-story Queen Anne has been operated by the Historical Association of Greater Cape Girardeau since the 1970s, and over those years, thousands of delighted local visitors and riverboat tourists have experienced firsthand the elegant architecture, social history and material culture associated with Cape Girardeau's boom years during the Victorian era. The Glenn family's colorful story is, likewise, central to the popular historic site's interpretation. Like so many of his business contemporaries, David Andrew Glenn was a man with little formal schooling but natural genius and entrepreneurial instincts who established himself as an influential banker and one of Cape Girardeau's most accomplished merchants with his vast wholesale and retail firm, the Glenn Mercantile Company.

As befitting a man of his ascending status, Glenn married Lula Deane, the daughter of premier local architect Edwin Branch Deane. This Kentucky-born builder designed some of Cape Girardeau's most celebrated nineteenth-century homes, including the Glenn House,

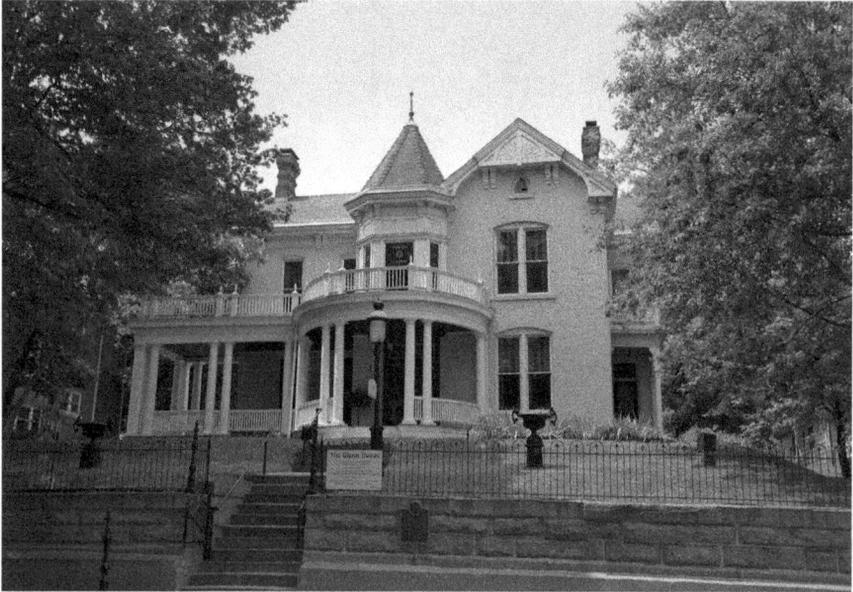

The Glenn House at 325 South Spanish Street is operated by the Historical Association of Greater Cape Girardeau and open to the public for tours and programs. *Courtesy Cape Girardeau Convention and Visitors' Bureau.*

which he constructed as a wedding present for his daughter. The Glenn family eventually added several substantial improvements to the home in the 1890s, such as the cutting-edge technologies of electric lighting and indoor plumbing. Around 1900, they also oversaw a final major renovation that transformed what had been originally a brick farmhouse into the more popular Queen Anne style, complete with veranda, wraparound porch and pyramidal roofed turret. These are the ornate Victorian architectural features inside and out—including stenciled ceilings, elaborate woodwork and graceful slate fireplaces—that the historical association lovingly restored for future generations.

The Glenn family's life was not always as polished as the home's decorative fixtures, however, and in reality, the troubled stories that unfolded in the house contain more than a fair share of tragedy and untimely death. This seems to have held especially true for males, leading some to stop just short of using the term "cursed." David and

The restored front parlor of the Glenn House, where noted Cape Girardeau architect Edwin Branch Deane lay in state after his death in 1901. *Courtesy Cape Girardeau Convention and Visitors' Bureau.*

Lula were married in 1881 and moved immediately into the home, which was then still under construction. Over the next six years, three of their eventual six children died as toddlers, probably in the house. All were boys, and one, Virgil, passed away on Christmas Day 1884. Lula actually outlived all four of her sons, only one of whom survived to adulthood and died in 1949. Both of her daughters had sons who died relatively young as well, including Lula's grandson, who was born on Christmas Day 1919 and lived only ten days. Lula's father, Edwin Deane, the home's designer, passed away just as the Victorian renovations were being completed in 1901. He almost certainly would have had at least some hand in this substantial construction given his dedication to the house and the fact that he lay in state for several days in their front parlor.

By the second decade of the twentieth century, David Glenn's once bright career had entered a period of decline, and he and Lula were compelled to sell their grand home in favor of more modest accommodations. John Hunter purchased the house from the Glenns

in 1915, and his family remained there until the 1950s. One of the Hunter sons died in a riverboat explosion in the early 1930s, and Mr. Hunter died from the complications of a stroke in 1938. Oddly, the elder Hunter came back from the hospital to stay for a time in the home after suffering the initial stroke, but those close to the situation gossiped that not only had his physical appearance changed but also his demeanor bordered on unstable. Perhaps because his behavior frightened some neighbors to the point of believing him to be deranged, a dark folklore developed whereby Hunter is said to have knocked a little girl down the stairs. According to this unsubstantiated story, the child's family had been boarding with the Hunters for a while when he became upset at the youngster's behavior and accidently pushed the small girl. The fall supposedly broke her neck, and she died on the stairway just a couple of steps above the landing. Hunter himself passed away just months later.

Another boarder in the 1940s died in the small apartment above the adjacent carriage house. This African American man suffered from some type of cancer and spent his painful last days upstairs in this outbuilding, which by that time had long ceased to be used for housing the Glenns' carriage, harnesses and tack. When he was found dead in this space, which the historical association now uses for meetings and special events, he was completely alone and without family.

In one more unsettling turn of events, when Lula Glenn's daughter-in-law, Geraldine, finally passed away much later, her only remaining family members were so disgruntled at not receiving an inheritance that no one ever bothered to claim her remains from the funeral home. Eventually, the mortician cremated her and kept the ashes on site for a number of years before historical association volunteers heard of her plight and retrieved the urn. Her ashes were thereafter kept in the Glenn House parlor throughout the 1990s before enough money could be raised through donations to have them buried in the family plot at New Lorimier Cemetery.

These misfortunes, heartbreaks and deaths seem to have been etched into the very material of the Glenn House. Consider also that for most of the latter twentieth century, before its eventual renovation, the once opulent home had deteriorated considerably, falling further into disrepair and neglect with each passing year. Even after the tarnished and broken-down old Queen Anne was saved, for over forty years now as a historic site, it has remained unoccupied. To everyone's knowledge

only two brave persons have dared spend all night there in that entire time. Little wonder, then, that each room, and every hidden nook and cranny, holds ghostly secrets that only now are beginning to be told.

Anxious visitors touring the home have commented to docents about hearing the faint sobbing of young ones emanating from certain rooms while the sounds of childish laughter came from others. Sometimes, these disembodied noises are so pronounced that after-hours passersby on the quiet sidewalk have taken the time to alert the association of what they heard coming from the pitch-black house. On other evenings, a local photographer has caught several images of what appears to be a misty figure resting on the front porch.

During a board of director's meeting a number of years ago, members were convened around the dining room table going over association business. Being wintertime, the sun had gone down early and left the gathering in the dim glow of an antique chandelier, which had been fitted for either electricity or kerosene. At one point in their deliberations, all the members of the gathering heard someone walking around in one of the bedrooms above them. As they all looked at the ceiling and tried to determine who among them had snuck away from the meeting to go upstairs, the footsteps traveled across the second-story hallway, the sounds alternating between padding along on the rugs and thudding on the hardwood flooring. Finally, the steps descended the stairway, and all eyes turned from the table toward the entry hall to see who the mystery person was. Yet even after the sounds fell silent, no living soul ever appeared on the stairs. Uneasily, the board members—prominent and serious individuals all—exchanged glances and nervous laughter in agreement that they had just witnessed something inexplicable.

Just a couple of Octobers ago, students from the university's honors program were touring the Glenn House in the evening for a little Halloween fun followed by the telling of some classic ghost stories in the carriage house. During the performance, the students and others in the audience began noticing a small shadowy figure, roughly the size and shape of a bird or bat, hovering behind the storyteller just above his head. At first glance, most of the gathering dismissed it as just some sort of reflection or shadow from the lighting, knowing full well that no living creature was flying around the room. But suddenly, the shadow began moving around the teller, picking up speed as it went as if in some sort of jerky dance. Then it darted out over the audience's head,

bouncing amid the exposed roughhewn beams in what those present later thought to be a very deliberate and intelligent manner. In all, the whole episode lasted no more than a few seconds before the shadow retreated once more behind the teller, whooshing toward the stairs that lead to the loft apartment.

Although the Glenn House has hosted other ghost story–telling events like this during the Halloween season and is, of course, one of the requisite stops on haunted walking tours each fall, it is not always the falling of the leaves that arouses some spirits here. Maybe it specifically has something to do with the two Glenn boys who died on or around Christmas, but that holiday often can be the most active time of the year for the Glenn House ghosts. Beginning in November, volunteers spend hours giving the home its much-awaited Yuletide makeover by decorating several splendid trees and fastening countless ornaments throughout the house along with beautiful evergreen wreaths and garlands. The Victorians created many of our more modern Christmas traditions, and docents at the Glenn House pride themselves on annually re-creating that cherished Dickensian Christmas from the turn of the twentieth century.

Still, several of those same festive volunteers will tell you that unsettling things can happen during this otherwise joyful time. Decorations are moved around, often found adorning a completely different fixture in another room of the house. So, too, have gifts left under the trees been rearranged, sometimes placed in symmetrical patterns on the floor while on other mornings stacked one on top of another. If this sounds like the work of small, childlike spirits as some docents speculate, consider also the year not long ago when meticulously wrapped packages left in the house overnight were discovered the next morning opened and strewn about as if they had been played with.

Bonnie Chaudoir is a Historical Association board member responsible for decorating the Glenn House each Christmas, and while she has never experienced anything out of the ordinary with the gifts, other bizarre occurrences have certainly gotten her attention. During an interview with KRCU radio, Bonnie recalled her own eerie brush with the phantom little girl whom many believe still sits patiently on the main stairway where she tumbled in the 1930s. This beautiful old staircase, with a well-worn wooden handrail, ascends the left-hand side of the magnificent entry hall, and like most volunteers, Bonnie has been up and down its richly carpeted steps so many times that she hardly pays much attention anymore.

The top of the grand Glenn House staircase on the second floor. The Glenns' master bedroom is the first door on the left. *Courtesy Cape Girardeau Convention and Visitors' Bureau.*

"Now I [had] done this many times," she explained to the interviewer about climbing the stairs on that particular night, and she had "never, ever had a problem." Even while standing at the base on the main floor, she said, "I still didn't see anything or hear anything. It was just really strange. But I started up the stairs and approximately there—up to two steps above it—was absolutely ice cold," she recalled. "And I thought 'Well that's strange.' I went almost to the top, came back down to see if there was a draft coming with this door open, it was still ice cold."

"Ice cold. It was the strangest thing," Bonnie reiterated. "See, if you open the stair door up there that goes out onto the back porch, you get a wind through here like you wouldn't believe. But it was just right here that was cold. The stairs below and the stairs above were the same temperature as the house, which was cool, because we're talking about November."

Having volunteered so many years of service at the Glenn House without incident, Chaudoir initially did not know what to think about

the sudden cold spot on the staircase and, later that evening at dinner, sought the opinion of a friend. Her friend began to put things in perspective. "You need to stop and think," she said, "I have a feeling that you had an encounter with a spirit that may still be in the house."

A skeptic, Chaudoir mostly shrugged off her friend's paranormal suggestion until the following January, when a series of mysterious happenings in the Glenn House got her thinking about spirits again. She had been working throughout the house for hours taking down the Christmas decorations with the help of another volunteer, a local florist, and the two were finishing up in the kitchen. "We were just getting ready to go out the door, and we heard somebody walk from the master bedroom, across the hall and into the nursery," Bonnie remembered. "It's very distinct when you walk upstairs, the house being old, you can hear anyone moving around at any time. She looked at me because we knew no one else was in the house. We had just checked the whole house and locked it. And she said, 'I didn't hear that, did you?' I said, 'No, I really didn't,'" and she said, 'Well let's get the *heck* out of here!' and that's not a direct quote."

Understandably, Chaudoir kept this second spectral episode to herself, fearing that if other volunteers knew she was feeling cold spots and hearing ghostly footsteps on the second floor, they might begin to question her sanity. Yet neither did she feel comfortable venturing into the Glenn House alone anymore, a growing fear that often impacted her duties there and became increasingly hard to hide. After one board meeting in particular, the board president asked her to take something to a storage room upstairs. At first, Chaudoir innocently asked her if she would mind going with her upstairs but, during the course of their conversation, finally confided about why she refused to go alone. The board president in turn shared Chaudoir's stories with several other volunteers, who, they came to find out, had been keeping mum about their own strange tales and refusals to enter the home after dark. Together, they began a research project to hopefully determine what or whom they might be dealing with.

One of the first pieces that came together involved the mystery of those cold spots on the stairs. "I have learned that a young girl, I'm not quite sure of her exact age, fell to her death, and they found her approximately in the spot where I felt the cold air, closer to the bottom," Ms. Chaudoir explains of the alleged Hunter incident. "At the time there was conversation as to whether she had actually fallen, or if she

was assisted with a push," Chaudoir continues, "but nothing ever came of the investigation."

Other volunteers wonder if that same girl is also responsible for mischievously setting off the home's electrical call system or if one of the Glenn boys is behind those pranks. When David Glenn modernized the house around the turn of the century, one of the nifty conveniences he had installed was a state-of-the-art Victorian system of electric bells that could be activated from virtually any room in the house and ring in a central box mounted on the kitchen wall. From there, servants could determine what room was summoning them and dispatch themselves accordingly. The bell system still works today, but because of its advanced age, it is rarely used. That is, of course, except on a few occasions when volunteers have been working in the kitchen and heard the bells go off for the upstairs bedrooms. Invariably, after a close investigation, no one is found on the second level, but when the docents return to the kitchen, almost immediately another bell from yet another room would beckon. This childish "game" can go on for quite some time and has, in fact, been known to actually outlast some volunteers.

Sam Sampson-Kincade worked for a brief time as a live-in curator at the Glenn House, and from his perspective, the bell system is indeed haunted, but not by a dark, or even a particularly naughty, child-like force. Sampson-Kincade had heard the various creepy stories about the home when he agreed to move into the carriage house apartment while still a historic preservation student in exchange for administering the property. Like Bonnie Chaudoir, he remained unconvinced as long as he could, beginning to change his mind only after witnessing lights coming on in various rooms late at night that were already turned off by the time he walked over from the carriage house to inspect.

If the lights got his attention, the bell system was the tipping point. Not only do the servants' bells ring in the kitchen, but they also go off in the carriage house so that the Glenns could alert the staff out there to ready the horses. Sampson-Kincade recalls that initially he would be awakened by a bell set off in the dining room. Yet when he got out of bed, crossed the yard and entered the house, all would be still. By the time he finally settled back in bed, however, the bell from the master bedroom would go off. This back-and-forth routine, almost a tug-of-war it seemed, would continue between the hours of 10:00 p.m. and 2:00 a.m., and the longer he lived there the more frequently it occurred.

Sampson-Kincade's encounters with the spirits of the Glenn House reached a crescendo of sorts one evening when he entered the back door of the kitchen to lock up for the night. At about 6:30 p.m., with the long, late autumn shadows already falling across the furniture, he swung the door into the adjoining butler's pantry wide and in doing so struck something standing in the dusky room. Instantly, he caught a glimpse of a man slightly shorter than himself dressed in a white semi-formal business suit, and his first reaction was that he had accidently hit the board of directors' president with the butler's pantry door. But within a split second, the well-dressed specter disappeared, leaving Sam to contemplate what he had just experienced.

Sampson-Kincade can tell you now that although he never got a good look at what he truly believes was the ghost of David Glenn, he nevertheless got the impression, if you will, that the entity had on a white shirt with a high Victorian collar and no tie. According to Sampson-Kincade, it was as if the former head of the household had come home from a hard day's work and was in the process of loosening up. Those feelings are consistent with other brushes Sampson-Kincade had in the house that gave him the sense that he was in the company of an authoritative presence. Accordingly, Sampson-Kincade came to an understanding that both David and Lula Glenn still reside in the house and are living out one of the happier periods of their earthly lives. He never felt threatened by them in the slightest but does think that the ringing of the servants' bells was their otherworldly way to "train" the new help; first, Mrs. Glenn in the dining room and next, Mr. Glenn in the master bedroom. Sampson-Kincade also does not think that the Glenns are trapped in the house but rather believes them to possess the ability, just not the desire, to move on.

Even though Sampson-Kincade left the Glenn House for another job years ago, he still counts himself among those volunteers who work there as a labor of love and identifies with the many visitors who have developed a real affinity for the beautiful Queen Anne. That being said, he also recognizes that even some of the Glenn House's most devoted staff still choose to avoid particular bedrooms, especially the nursery, because of something they have heard or the peculiar way it makes them feel. The air is heavier in places, like the compact carriage house apartment, which makes it harder for them to breathe. Even those unable to detect cold spots still sometimes complain of headaches while navigating the stairs. There are also a few who simply will not enter the

house alone and more still who will not go in after dark. Nonetheless, Sampson-Kincade tries to reassure those who are fearful of the unexplainable phenomena that come with working in the Glenn House. After all, he points out, the house was never more active paranormally, nor the feelings more welcoming toward him, than during the time after he put in his two-week notice. The Glenns, he maintains, must have found his efforts on behalf of their beautiful home worthy.

SHERWOOD-MINTON HOUSE

Perched genteelly over the decidedly more modern neighborhood at the corner of Washington Avenue and North Middle Street, the antebellum Sherwood-Minton home is considered the queen mother of Cape Girardeau's haunted houses. Constructed of bricks hand-pressed by slaves with nearly soundproof walls at least eighteen inches thick and an imposing eight-foot-tall front door, this two-story, Greek Revival mansion certainly looks the part. Its architecturally classic design features, smooth stuccoed exterior walls and wrought iron speak of a long-ago romantic age. The pronounced vertical lines of the engaged columns and squared parapet likewise lend a natural air of southern graciousness, at once hospitable and oddly aloof.

Without question, the Sherwood-Minton house has a ghostly pedigree as well. For over 150 years, Cape Girardeau has been fascinated by its tales of a hidden tunnel leading to nearby Old Lorimier Cemetery and spooked by its stories of the embittered spirit of an escaped slave or the phantom soldiers who wander the rooms where they died. The high turnover, relatively short duration of ownership and periods of vacancy—the property has changed hands more than twenty-five times—mean that the home is for sale quite often. This in turn reflects and reinforces the aura of superstition. Even today, when the house is on the real estate market, agents feel ethically bound to disclose its macabre history of the paranormal and unexplained to potential buyers because of liability concerns.

Built in 1846 by the Reverend and Mrs. Adriel Sherwood on four and a half acres once owned by Louis Lorimier, the home originally

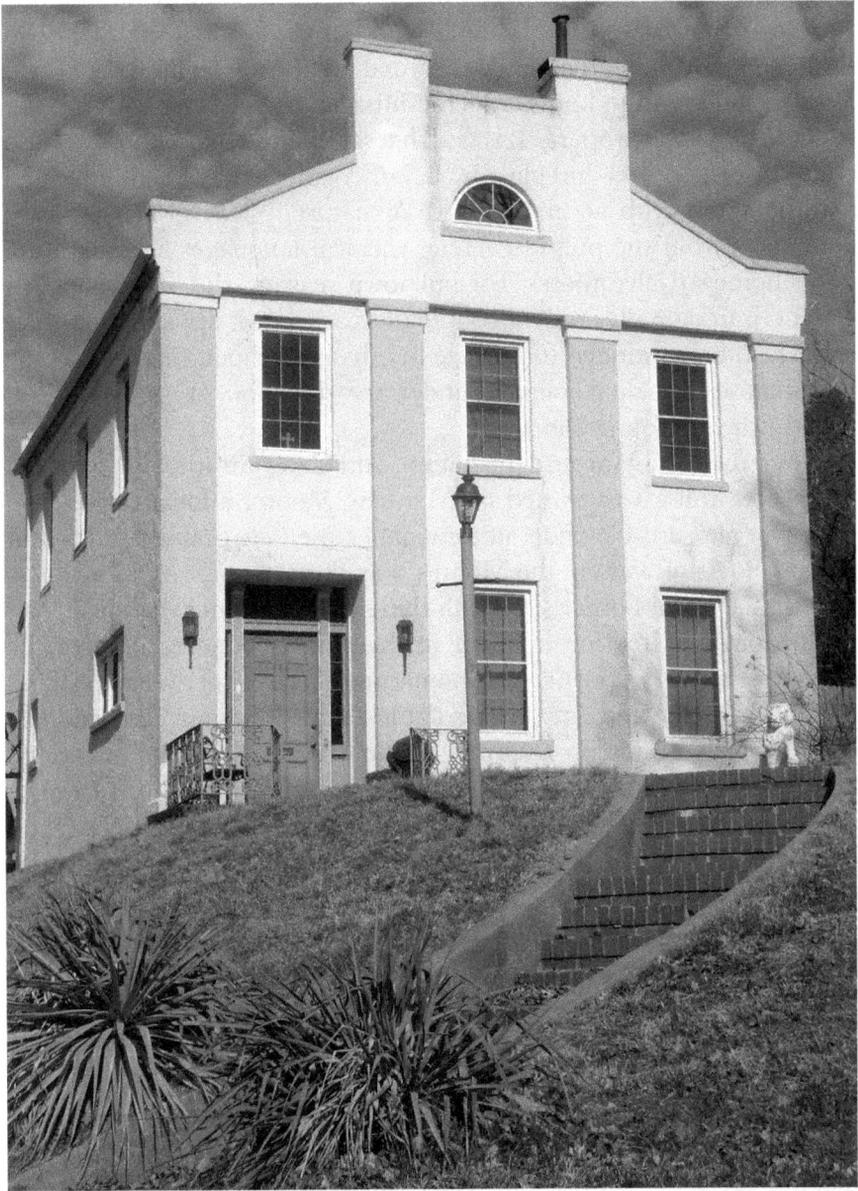

The Sherwood-Minton House is Cape Girardeau's most enduring and notorious haunt.
Photograph by Jeanie Rhodes.

functioned as both the family's private residence and a day school. Reverend Sherwood, the pastor of the Baptist Church, hired Edwin Branch Deane, the same highly regarded architect who built the Glenn House, to design the home, which craftsmen constructed with lumber cut directly on the property. It is said that slaves and other bondsmen also crafted all the bricks and glass by hand. A cultured and well-educated man of letters with an abiding love of nature, the reverend spent his time away from the pulpit teaching classical languages and literature in his home's twelve rooms. For unknown reasons, the Sherwoods left Cape Girardeau after only a couple of years, but it appears that their former home continued to operate briefly as a school, this time as the Washington Female Seminary under the direction of the Reverend David Edward Young Rice.

When the Civil War tore the nation, and Cape Girardeau, apart, the Sherwood house was owned by Matthew Moore, a local lawyer and publisher of a pro-Confederate newspaper, the *Cape Girardeau Eagle*. But the harshness of war cut the Moores' stay short as well.

Missouri was a border state with slaves that, in principle, stayed with the Union. The tension inherent in this arrangement established the parameters for most political, economic and social life between 1861 and 1865. While blue and gray armies battled across the state early and late in the Civil War, intense guerrilla fighting raged in the interim. Cape Girardeau felt its share of this strain, with the war leaving almost no aspect of life untouched. A key strategic location along the Mississippi River and Crowley's Ridge, the town remained occupied by the North for most of the war. This made life hard and uncertain. The mood and morale of the people fluctuated widely. As hard money became increasingly scarce and trade along the river disrupted, the recently booming economy slumped for nearly a generation. Divided sympathies tugged at the social fabric. Many of Cape Girardeau's 2,663 citizens were European immigrants, primarily from Germany, who tended to support the Union. Areas to the south generally cast their lot with the Confederacy. Church congregations split, and some in the community took advantage of the circumstances the war created to revisit old feuds and settle old scores. The harsh provost marshal system imposed by the military during the war and the punitive treatment of Southern sympathizers by the Radical Republicans afterward only aggravated these ruptures.

From a military standpoint, Cape Girardeau was of great strategic value to both sides. The first high ground on the Mississippi above the

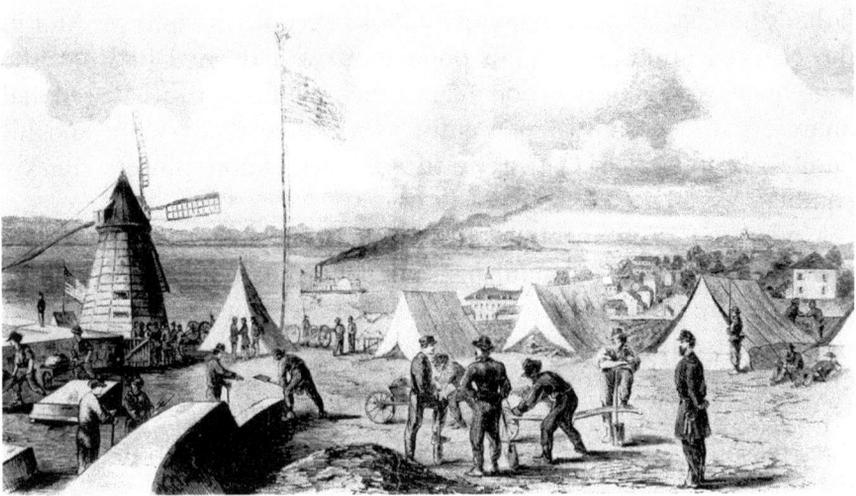

Union troops built four permanent fortifications in Cape Girardeau to cover the Mississippi and all roads into town. This is Fort A on the bluff at the end of Bellevue Street, which guarded the river to the north with its artillery pieces. A windmill on the site, which gave it the nickname "Windmill Hill," served as a lookout tower. Southern sympathizers were warned that in the event of a rebel attack, Fort A's guns would be fired into the town, a potentially powerful deterrent, considering many sympathizers were property owners. *Courtesy Southeast Missouri State University Special Collections and Archives.*

confluence and the largest town on the river from St. Louis to Memphis, it also sat atop a military road that ran along Crowley's Ridge into Arkansas. But for the Union, military failures in central and southwest Missouri early in the war made Cape Girardeau, and southeast Missouri, absolutely vital. Accordingly, Federal troops occupied the town from July 1861 to August 1865. Specific units from states like Illinois and Wisconsin came and went during the war, but their objectives remained the same. First and foremost, Union troops stationed in Cape Girardeau were to keep the river open and defend against any Confederate invasion of the north "by land or water." Secondarily, from this base of operations, they were to subdue Confederate guerrillas, pacify Confederate sympathizers and keep the region's roads open.

As far as Matthew Moore was concerned, according to local accounts, drunken soldiers from an Illinois regiment insulted one of his daughters

during the early days of the occupation. Little doubt existed that the incident was at least in part motivated by the soldiers' disdain for her father's politics; at least many of the townspeople thought so. And in the charged atmosphere of a population with divided loyalties, the subsequent disciplinary action against the men further fueled sectional animosity and hostility. Apparently, so much so that Moore and his family abruptly fled Cape Girardeau, and Union officers quickly commandeered the house.

Under the army's control, the Sherwood home served initially as officers' quarters. Careful inspection of the stairway still reveals gouges in the woodwork from the spurs on the boots of the Wisconsin cavalrymen. As the bloody conflict dragged on and the toll of occupation grew, the Union eventually repurposed the house as a smallpox hospital to treat those afflicted with this dreaded epidemic. Doctors believed the thick masonry walls and large shade trees would help keep the feverish patients cool.

When peace finally came in 1865, the army relinquished the premises, but the home still sat vacant for several years. These months of abandonment immediately following the war are probably the genesis of the public's perception that something was wrong with the once celebrated house. Most people shunned the property altogether, afraid to venture too close to the scene of such recent suffering and death. Some, however, began circulating the first known stories of its ghostly inhabitants, confessing that they had seen the shadowy figures of soldiers moving about the house through the windows during the day. A few also told of watching hazy specters clad in tattered blue uniforms walking through Old Lorimier Cemetery toward the Sherwood house in the late night hours before finally disappearing through its massive front door.

Interestingly, a 1910 article in the old *Cape Girardeau Daily Republican* newspaper about a structural mishap at the home referenced a much older story about ghosts under the subheading of "The House Is Haunted." In what is most likely the first published account of spirits at the Sherwood home, the paper retold an 1867 story about local men investigating the strange goings-on in and around the recently abandoned military hospital. The article described how, ever since the war,

the appearance of ghostly visitors at frequent intervals made the house an undesirable one for a home. Many nights the tall, white form of a

departed soldier was seen moving about through the trees of the park surrounding the house, either disappearing into the ground, into the abandoned house or fading into the darkness of the somber grove of the park. The ownership of the house passed into the hands of a family named Morris, whose heirs had become scattered throughout the union; it therefore stood untenanted and uncared for, and the fact that it was haunted by the spirits of soldiers dead and gone made it all the more undesirable for a home.

It goes on to explain that

members of the Justi post, G.A.R. [Grand Army of the Republic], *hearing of the visits of the ghostly soldiers, decided to make an investigation, a committee was appointed and a watch was set. The members of the committee concealed themselves in the shrubbery about the place one night in June in the year 1867, and began their watch for the coming of the restless spirit. As the clocks about the village were striking the midnight hour, they saw a sight which caused their hearts, although they were the hearts of veteran soldiers, to thump within their breasts. From the cemetery across the way there glided toward them a tall specter, white clad, moving silently and slowly among the trees. Nearer it came, the faint moonlight giving it an uncanny appearance. The three men crouching breathlessly behind the shrubbery were almost spellbound with awe as the specter glided toward them, and in all probability would have fled, but that the ghost, unfortunately for himself, and probably owing to the dampness of the night air, was so un-ghostly as to sneeze.*

This is where the story unravels, as the reporter reveals the nature of the hoax:

That sneeze was the undoing of his ghostship, for it broke the spell which had held the watchers in check. A dash was made, and a few minutes later the ghost was flat on his back, and the familiar features of Philoh Smith, a well-known contractor and builder of Cape Girardeau, were lying uncovered in the light of the moon, which had come merrily out from behind the clouds. Philoh Smith, who owned adjoining property, had long desired to acquire the Sherwood place, and had resorted to the ghostly method of beating down the purchase price.

Despite the anecdote's ultimately amusing ending (almost a quaintly Victorian forerunner to classic *Scooby Doo* storylines), for a time in the last quarter of the nineteenth century, the house passed through several private hands. Each new sale seems to have not only confirmed the community's fears but also generated curiosity about the existence of those mysterious tunnels thought to connect it with Old Lorimier. In due course, the Minton family finally moved into the home in 1883 and stayed there for thirty-five years, making theirs the longest period of ownership and thus explaining the modern hyphenation of Sherwood-Minton. Mrs. Frances Minton, a widow who took in boarders for much of that time, passed away in an upstairs bedroom three days after Christmas in 1919. Nonetheless, over the next six decades, the Sherwood-Minton House continued this extended period of stable occupancy with only three more families calling it home.

While most older places with this type of history are generally assumed to be haunted, by the 1970s stories about the Sherwood-Minton House were so prolific, and in some cases so reliable, that they began to transcend mere folklore. Even skeptical former owners conceded that they had experienced phenomena while living there that simply defied logical explanation. Faint sounds of muffled whimpering and moans, as if a number of people were suffering together, disturbed their otherwise pleasant slumber, as did the terrifying, but rare, shrieks coming from the basement in the dead of night. Heavy, disembodied footsteps were heard clearly, thudding along the hallway planks on quiet nights, accompanied by the phantom clanking of spurs when the sounds made their way along the stairs. A particular upstairs hall closet door sometimes opened and closed by itself, its creaking hinges awakening family members who then anxiously lay awake in their beds trying to convince themselves it was only a dream. Likewise, several downstairs doors periodically swung wide when no human hands or gusts of wind were involved. And the huge front door made a shrill whistling sound almost like a song, loud enough that people jumped whenever the slightest breeze blew in from the south.

An adolescent girl got her very first, and possibly last, babysitting job in the Sherwood-Minton House because of these things that went clank in the night. She had been hired to watch the two young daughters of the family then in residence, and with meticulous attention to detail, she had prepared herself for this traditional teenage rite of passage into maturity. Prior to the evening, her parents questioned her about

whether she was ready for such responsibility and also if she minded spending an evening mostly alone, after the children went to bed, in that house. She answered in the affirmative, and for the first couple of hours, the babysitting went as planned. But indeed, after the little ones were asleep, the gravity of the situation finally settled in as she sat alone in the darkened living room with every scary story about the home racing through her mind. Faint tapping noises coming from the basement brought the situation to a head. She then heard footsteps coming down the stairs, hard strides and a metallic jangling with each footfall. Within minutes, her parents arrived in response to her frantic telephone call. Genuinely terrified, yet utterly humiliated, the babysitter then phoned the owners to explain that she could no longer stay in their house and that they must return home several hours sooner than expected.

Peculiar drafts are also known to chill some of the rooms and stairs even when there are no possible entry points for outside air. The persistent draftiness of one basement wall in particular, in conjunction with the presence of floating orbs and tapping, has compelled some residents to search there for that storied tunnel's entrance. Curiously, people have reported both hearing the sounds of tapping from behind the walls and also feeling a physical tapping on their bodies when they were in the basement. The fact that tapping would be associated with the location of a tunnel makes sense when considering those possible historic connections between the Sherwood-Minton House and Old Lorimier Cemetery. Remember that a tapping ghost haunts the neighboring cemetery and may well still be using the tunnel to retrace the underground means through which soldiers once got back into the house after burying disease-ridden corpses each night. Unfortunately, all efforts to excavate the tunnel have ultimately been in vain, yet these investigations are not without some tantalizing clues. At just the right angle, you can peer behind that drafty wall with flashlights and see what looks to be sandstone blocks, which may be precisely how the military sealed such a passageway to the cemetery.

There are those, on the other hand, who will tell you that while the Sherwood-Minton tunnel is very much real, its purpose predates the Civil War. The sandstone opening in the basement, they think, leads, not to the cemetery, but to the river as a cavernous route on the storied Underground Railroad constructed and operated by Reverend Sherwood himself. One of the second-story bedrooms, referred to for generations as the "slave

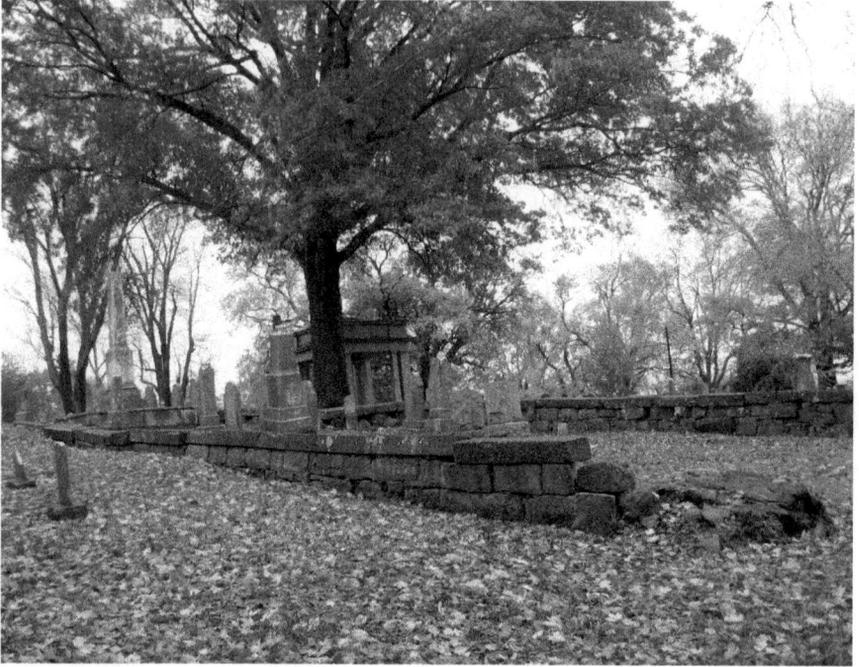

Old Lorimier Cemetery. *Courtesy KRCU.*

room," is an extremely active location associated with this period of the home's troubled history. Children who grew up in the house and their visiting playmates recall the door slamming shut and locking them inside for long, frightening hours at a time before adults could finally budge the otherwise normal antique knob.

The room always felt even more unwelcoming because of its cold starkness and lack of decoration. Nothing, it seems, will stay hanging on the walls. Picture frames, mirrors and shelves can be fastened into the plaster or otherwise secured, but within days, sometimes hours, they come crashing to the floor. These same adornments stay put just fine when hung anywhere else in the house, just not the slave room. Legend has it that in this spartan space, an escaped slave seeking passage through Sherwood's tunnel to the Mississippi, and ultimately free Illinois, was discovered by slave catchers. Trapped upstairs when they arrived, the young runaway could not make it to the safety of the tunnel without being detected, so she locked herself away in a small wardrobe. In the

agonizingly slow time it took the slave catchers to thoroughly search room by room, she crouched painfully and breathlessly inside the furniture piece. Even when the Southerners rummaged through that room, they found nothing until, upon leaving, one of them caught a reflection in a mirror hanging on the wall of just a strip of her tattered, homespun dress sticking conspicuously out of the elegant wardrobe. They pried her out and, despite her screams and commotion, dragged her from the Sherwood house to sell her back into bondage downriver. To this day, her unforgiving spirit refuses to allow not only the mirror that once betrayed her but also anything else hung in the room to remain on the walls. Some who have experienced the late night screams also swear it is a female voice they heard and not that of a soldier. And even in the mirrors she allows to hang in other rooms, people in passing have been startled to briefly glimpse what they describe as a contemptuous dark face peering out.

Those who have encountered the ghost of this runaway slave fear that in retribution, the tunnel was also sealed off by a larger party of slave catchers immediately after her capture. What they are afraid of are the slaves who might have still been hiding in its depths when the men bricked over the entrance in the Sherwoods' basement and the exit out to the woods by the river bank. These men, women and possibly children would have been trapped underground and left to agonizingly suffocate or starve. If this is truly the case, then the hauntings we associate with the tunnel may have nothing at all to do with smallpox or the cemetery. Instead, those specters that tap and weep in the cold, dark basement may be begging for release from the tomb that has imprisoned them underneath Cape Girardeau since almost a decade before the War Between the States even began.

Regardless, in October 2009, Rich Newman and Mike Uelsmann of Paranormal Inc. investigated the Sherwood-Minton House in the hopes of including their findings in a movie, *Ghosts of War*, about haunted Civil War sites the Memphis group is producing. At the time of their overnight work, the house was unoccupied yet again and languishing on the real estate market. The most recent owners had confirmed the team's research with stories about hearing footsteps in the basement and encountering a female apparition upstairs wearing an antebellum period dress. This information, plus the backlog of other stories they collected in Cape Girardeau chronicling the house, determined their overall investigative methodology and the strategic placement of their

four audio recorders, three video cameras, electromagnetic meters and other assorted infrared and ultraviolet camera equipment.

The two paranormal investigators, who have been working together for nearly two decades, were not disappointed by what they found. In over twenty hours of raw video and audio recordings, a significant portion of which came from the basement, Paranormal Inc. captured over fifty separate EVPs. When analyzed, many of the EVPs resemble soft moaning sounds and murmurs, but several instances were determined to be disembodied voices speaking through the recording devices. Meters throughout the house also picked up a significant number of EMF spikes, which was all the more significant considering that the electricity had been turned off for quite some time while the house sat vacant. Newman and Uelsmann told local reporters that aside from their electromagnetic readings, they could actually feel a tangible electronic charge in the air without any equipment at all. A number of their batteries were drained over the course of the investigation as well, leading them to hypothesize that the ghosts were starving for power and desperate to absorb it from wherever possible.

Taken together, the evidence led the men to the conclusion that the Sherwood-Minton House was indeed the site of substantial paranormal activity. Two spirits with which they communicated particularly intrigue them: a grown man and a little girl. Could this be the protective Matthew Moore and his offended daughter? Or is it a slave family? More research will be necessary to put Paranormal Inc.'s theories to the test, and toward that end, they have interviewed a number of people with connections to the house and even enlisted the help of local real estate agents. Together they hope to not only make a fuller accounting of those souls still inhabiting the old mansion but also possibly paint a clearer picture of why they are bound within its deep brick walls.

At least one anonymous former resident unequivocally agrees that the Sherwood-Minton House is haunted and, to her mind, with the ghosts of those unfortunate souls who died there during the war. But she remembers never having felt fearful all the time she lived in the home because of an overriding sense of peace she believes the dozens of spirits residing there possess. The woman witnessed firsthand shadowy figures in uniform passing through some rooms in the evening and standing sentinel in the windows by day. Some nights, the pitiful crying roused her from her sleep, but the prevailing feeling was one of compassion, not terror. So, too, did she take a measure of peacefulness

when she awoke to find translucent doctors serenely keeping vigil over her bedside. The young lady recalls tracing the gouges on the stairs with her fingers and sitting alone in the basement by where she assumed the tunnel opened, but never once did she consider fleeing the way it is often speculated that other families have.

In fairness, the woman knows hers is a decidedly minority opinion and freely admits that there are other houses in this very neighborhood along with areas in Old Lorimier Cemetery that absolutely terrify her. But she offers as evidence the well-known story of a workman whose life was actually saved by the home's unseen residents. While balancing himself atop a ladder two stories off the ground, this roofer lost his grip on the edge of the house and began falling backward. His co-workers were not close enough to reach him quickly, and they watched helplessly as the ladder tilted backward almost as if in slow motion. With no gutter to grab hold of, the worker braced himself for the fall, which was potentially deadly given that the abrupt slope of the yard meant he would plummet onto the asphalt of Middle Street. Yet at the last possible second before he went completely over, the ladder inexplicably steadied and forcefully reversed its course back toward the roofline. Not only did the ladder crash up against the house, thus averting the fall by defying gravity, but his friends later described in amazement how something unseen appeared to catch the man by the jacket and drag him onto the safety of the roof.

The past occupant and worker have discussed this mysterious episode at length and agree that those same entities she watched walking the upstairs halls in the old hospital are still committed to the preservation of human life. In fact, they point out that a little research in the archives corroborates their theory of compassionate spirits. Lightning struck the home in the first decade of the twentieth century during the Minton years, and a few months later, in 1910, the north wall collapsed as a result of the structural damage sustained. Several people boarding in the house at the time, including a number of small children, should have been crushed by all accounts. But somehow they were shepherded out of harm's way by a force onlookers were at a loss to explain.

Perhaps, as the woman truly believes, we are misunderstanding the forces that remain so active in her old house. Their strange manifestations and unfamiliar attempts to make contact are unnerving to be sure and often extremely frightening. Could it be, however, that they simply hunger for some fleeting engagement with our human

world? Does contact with us, either deliberate intervention in times of crisis or the reverberating echoes of their time-worn routines, satisfy an ageless longing for a last flicker of humanity? If so, then we have less to fear from the Sherwood-Minton House and, for that matter, the other ghostly sites in Cape Girardeau. Maybe, just because a place is haunted, we do not have to be scared of it. Then again, maybe not.

BIBLIOGRAPHY

Barile, Mary Collins. *The Haunted Boonslick: Ghosts, Ghouls & Monsters of Missouri's Heartland*. Charleston, SC: The History Press, 2011.

Barry, John M. *Rising Tide: The Great Mississippi River Flood of 1927 and How It Changed America*. New York: Touchstone, 1997.

Brown, Alan. *Ghosts Along the Mississippi River*. Jackson: University Press of Mississippi, 2011.

"Do You Believe in Ghosts?" *Southeast Missourian*, October 28, 2006.

"The Ghosts of Cape Girardeau." National Public Radio, KRCU. Cape Girardeau, MO, October 2009.

"Ghosts of the Mississippi." National Public Radio, KRCU. Cape Girardeau, MO, October 2010.

"Historic Walls Fall to Ground." *Cape Girardeau Daily Republican*, June 29, 1910.

Longo, Jim. *Haunted Odyssey: Ghostly Tales of the Mississippi Valley*. St. Louis, MO: Ste. Anne's Press, 1986.

Marks, Ken, and Lisa Marks. *Haunted Hannibal: History and Mystery in America's Hometown*. Charleston, SC: The History Press, 2010.

"The Mascotte Disaster." *New York Times*, October 7, 1886.

Neumeyer, Tom, Frank Nickell and Joel P. Rhodes. *Historic Cape Girardeau: An Illustrated History*. San Antonio, TX: Lammert Publishing, Inc., 2004.

"R.B. Oliver, Jr., Attorney, Dies." *Southeast Missourian*, June 7, 1971.

"67th Anniversary Recalls River Tragedy Near Neelys Landing," *Southeast Missourian*, October 27, 1936.

"Steamboat Disaster on the Missippi." *Indiana [PA] Messenger*, November 3, 1869.

"Terrifying Tales of SEMO: Three Haunted Legends of Mayhem and Murder That Persist on Campus." *Capaha Arrow*, October 31, 2012.

"Your House Is Haunted." *Southeast Missourian*, November 1, 1983.

Websites

http://paranormaltaskforce.com/pike.html.

http://voices.yahoo.com/the-top-five-most-haunted-hot-spots-state-of-3431088.html.

www.castleofspirits.com/stories04/rosetheatre.html.

www.ghostreconparanormal.com.

www.missourighosts.net/capegirardeau.html.

www.theshadowlands.net/places/missouri.htm.

www.semissourian.com/blogs/1481/entry/44269/.

www.semissourian.com/blogs/1481/entry/44885/.

ABOUT THE AUTHOR

Joel P. Rhodes is a professor in the History Department of Southeast Missouri State University. Raised in Kansas, he earned a BS in education from the University of Kansas before earning his MA and PhD in history from the University of Missouri–Kansas City. His teaching and research interests are in Cold War–era American political and social history, public history and the southeast Missouri region. Dr. Rhodes's articles have appeared in the *Missouri Historical Review*, and he has written *The Voice of Violence: Performative Violence as Protest in the Vietnam Era* and *A Missouri Railroad Pioneer: The Life of Louis Houck*. He also co-authored *Historic Cape Girardeau: An Illustrated History*. Dr. Rhodes serves on the board of the Missouri Humanities Council, State Historical Records Advisory Board, Missouri Association of Museums and Archives, the Colonial Fox Theatre Foundation and the Historical Association of Greater Cape Girardeau. He also co-produces the Cape Girardeau Storytelling Festival. He lives in Cape Girardeau with his wife, Jeanie, and their three children, Alex, Olivia and Ella.

www.ingramcontent.com/pod-product-compliance
Lightning Source LLC
Chambersburg PA
CBHW060809100426

42813CB00004B/1004